179.92

£6.95

GENTLEMEN PHOTOGRAPHERS

The Work of Loring Underwood and Wm. Lyman Underwood

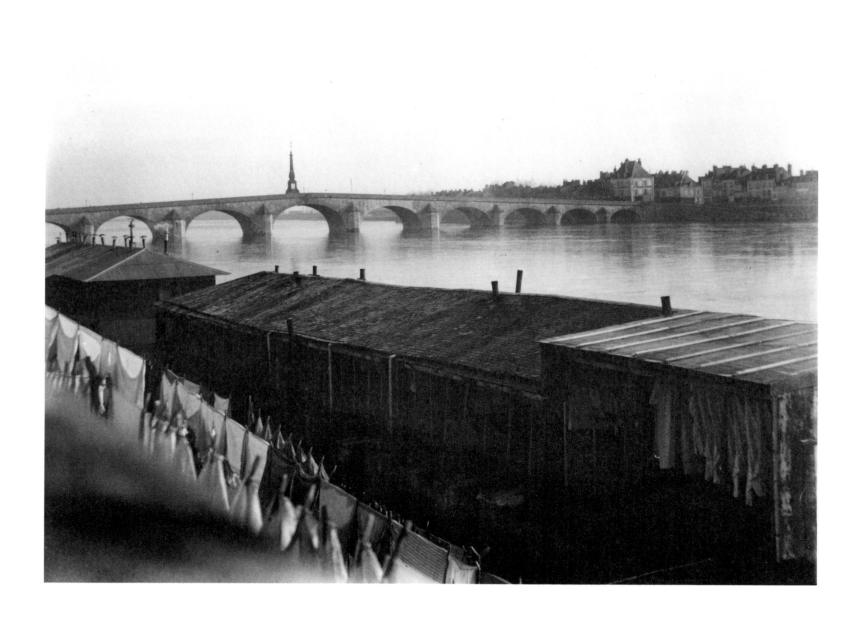

GENTLEMEN PHOTOGRAPHERS

The Work of Loring Underwood and Wm. Lyman Underwood

Edited by

ROBERT LYONS

with Essays by

CAROL SHLOSS & JOEL SNYDER

Introduction by

GEORGE C. SEYBOLT

THE SOLIO FOUNDATION

DISTRIBUTED BY NORTHEASTERN UNIVERSITY PRESS · BOSTON

Library of Congress Catalog Card Number 86–63033

ISBN 0–940097–00–1 (Hard Cover)
ISBN 0–940097–01–X (Soft Cover)

front cover:
Topiary Garden, Wellesley, MA, c. 1914: Loring Underwood

back cover:
Wm. Lyman Underwood and Bruno, Self Portrait, 1905

frontispiece:
Europe, c. 1900, Loring Underwood

CONTENTS

ACKNOWLEDGEMENTS

ROBERT LYONS

This project could not have been realized without the cooperation and support of many individuals and institutions. For their help during the initial phase of the project I owe my thanks to George C. Seybolt, chief executive officer of the Wm. Underwood Company; the Museum of Natural History in New York City, the M.I.T. Historical Collections, Mrs. Helen Underwood Baker, Mr. Julian Underwood, Bill and Beth Bagnall, and, in particular, Kirk Simon, without whose assistance the early years of printing, cataloging and conservation treatment would never have been accomplished.

I wish to thank those individuals who provided insightful and significant advice throughout this project: Clifford Ackely, Curator of Prints, Drawings and Photography at the Boston Museum of Fine Arts; John Szarkowski, Curator of Photography at the Museum of Modern Art; and, most importantly, Alan Trachtenberg, Professor of American Studies at Yale University. I am deeply grateful for the constant energy, wisdom, and insight of Jerome Liebling, Professor of Film and Photography at Hampshire College, throughout the entire course of this project.

Other institutions that have supported the project, and to which I owe gratitude include: Hampshire College, Pet Food Company, the Christian Science Church, Yale University, and Northeastern University Press and its director, Bill Froelich.

The book would not have come to fruition without the generous help of Esther Johnson, Lorna Sagendorph, David McAlpin Sr., James L. Johnson, Jennifer Johnson, the South Branch Foundation, and, especially, Pamela E. Mack, who has so graciously given her time and faith to the project. I thank the following individuals for their personal support throughout the project: Tom Edmondson, Douglas Dubois, Dorothy C. Belknap, Nathaniel Gray, Melvin and Celia Lyons, Mitch Epstein, Joseph DeFazio, and my wife, Hannah C. Wiley.

Finally, I am indebted to these individuals whose support during the final stages of production has been critical: Susan Lezon, my assistant at the Foundation, whose numerous hours of work helped see the project to completion; Joel Snyder for his concise essay that creates a context for the gentleman photographer; Carol Shloss for her illuminating writing about the lives and times of Loring Underwood and Wm. Lyman Underwood; and Douglas Munson of the Chicago Albumen Works, my friend and colleague, who has assisted me in each phase of planning and execution, encouraged me during difficult periods and given generously of himself and his expertise toward the completion of this project.

PREFACE

Robert Lyons

In the past ten years, the role of photography has broadened considerably, and the medium functions today not only in its traditional manner as a vehicle for factual recording, but also as a means for exploring artistic expression. The increased public awareness of photography as an art form has affected our whole view of photography and its history. Presently scholars, critics and historians are re-evaluating the way they understand old photographs and ascribing criteria from the past twenty years to their interpretation of these photographs. This development, while enhancing and adding new levels of appreciation for old photographs, has not been without its price. In many cases the historical value of the photograph and the context within which it was created are ignored, with importance given principally to its artistic merit. There are, however, many nineteenth century photographs – depicting scientific developments, historic events, and social phenomena – that are valuable for their documentary as well as their artistic merit. These pictures, coupled with other documents of the period (newspapers, letters, books) speak with a special poignancy of the emergence of major industries, and of the resulting impact on social structures and attitudes.

The view from the "underside" of America's expansive new society is relatively well known to photography lovers, thanks to such documentary artists as Jacob Riis and Lewis Hine. The view from the other side – the perspective of the managerial rather than the working class – is not so widely known, and that is one of the reasons that the work of Loring Underwood and Wm. Lyman Underwood, the junior heirs to an industrial fortune, is so interesting.

The Underwood brothers were members of an educated elite, and used the privileges of their class to comment photographically on timely social issues. In Wm. Lyman's case particularly, as Carol Shloss's essay here shows, this meant confronting the deficits as well as the benefits of late nineteenth-century progress. The pictures, articles, and books of the Underwoods illustrate clearly the idea of *noblesse oblige*.

Their work also has a value beyond the historical. In addition to giving us a glimpse into a specific social and economic milieu, many of the Underwood photographs are also fine artistic pieces in their own right. What drew me initially to the Underwood preservation project, in fact, and what has held me to it for nearly a decade, was the richness and luminescence of their work.

Their prints are not dramatic new discoveries either artistically or historically, but they do provide a rare record. It is the record of two socially comfortable but technically restless individuals who managed to capture on film a particular period of history, encompassing both the mundane and privileged aspects of upper-class America at the turn of the century.

For me, the fascination of the Underwoods' work and of this book in particular has been the chance to interweave written documents with photographs and social history to produce a unique view of a rapidly industrializing society. It is my hope that, for the artistically-minded and historically-minded alike, it will provide a realistic tapestry, embodying what I have come to call the world of the "gentleman photographer."

INTRODUCTION

GEORGE C. SEYBOLT

The two brothers whose work is presented in this book were the grandchildren of William Underwood, an Englishman, who emigrated from England to Boston early in the 1820s. North America had been discovered by Europeans three and a third centuries before, and since then Europe had been engaged in the long, lurching process of advancing civilization. Indeed, the systematic settlement of the American continent had begun only two hundred years earlier, in the 1600s.

In these various spaces of time this continent and its new country had made remarkable progress in unifying its society, supporting its commerce, and stabilizing its government.

Mr. Underwood, himself an unusual man – alert, flexible, energetic, imaginative, and blessed with good judgment – found conditions favorable to starting a business. He did so in 1825, laying the groundwork for the company that would eventually become the Wm. Underwood Co., a pioneer in the canning of food. He continued in the business until his death in 1865.

William Underwood and his wife had a large family, and a number of children might have taken over his business. When it came time to choose his successor from the second generation, it would appear that the old English custom of primogeniture prevailed. There is reason to believe that Mr. Underwood would have done better in selecting a junior heir, for the business did not prosper.

Fortunately, a resolution to the difficulties was found from within the family, among the brothers of the third generation. The record makes it clear that Lyman, Loring, and Henry Underwood possessed, in varying degrees, the qualities and abilities of their grandfather.

Since the family standard of living always rested on the progress of the Wm. Underwood Company, the appearance of the first son, Henry, was fortuitous. Wasting no time in shearing off the odds and ends and the involvements accumulated by his father, he moved to concentrate this little company's efforts, focusing it, and simplifying its management and ownership. He insured a reliable and sufficient standard of living, thus providing the secure base for his brothers, Lyman and Loring, to give their time to noncommercial interests.

When I agreed to enter training to become the chief executive officer of the Wm. Underwood Company in 1950, the presence of the three brothers could still be felt, although their deaths had occurred twenty or more years earlier. The senior management chosen and trained by Henry thirty to forty-five years earlier was still in place, and frequently recalled him as sort of an oracle. The ghosts of Henry, Lyman, and Loring were present at every policy meeting, and the relationships between the three brothers were a matter of common conversation.

The conversation made it clear that the two "nonbusiness" brothers, Lyman and Loring, were, no less than Henry, individuals of strong character, active imaginations, and possessed a great ability to think through problems to sound conclusions. All three had a zest for asking questions and producing viable answers, and although their thinking was seldom systematic, their applied intelligence was considerable. It was not surprising, therefore, that I became fascinated by their personalities and their effect on the 125-year-old business. To satisfy that fascination, I set about to organize material, data, and artifacts – anything from any source about the company and its leaders.

This resulted in the collection of thousands of pages, labels, early accounts, and letter books; research into possible sources of material such as courthouses in Maine and Massachusetts, where Underwood had had operations; advertisements for material in collectors' magazines; drafts of histories; and the acquisition of a collection of rare recipe and cook books documenting the early formulations and use of company products. This last project provided an especially important resource, since there were practically no canned products made before 1900 which Underwood had not produced, frequently as the product's initial canner. Hundreds of slides of Lyman's and Loring's work were procured from M.I.T., where Lyman had done research and lectured. Museums gave up their bits and pieces too. All of this came together over several decades, thanks to the understanding cooperation of many friends and institutions.

The investigation into the Underwoods' history brought with it responsibilities for conservation, scholarship, and use.

The conservation problem was met first by including a climate-controlled room in our new company building, first occupied in 1972, on Route 128 in Westwood: here the paper, metal, wood, glass, and stone artifacts were stored adjacent to our library. Our librarian/archivist began to organize the collections, helping to supply the basis for articles in such journals as the *Saturday Evening Post*, *Fortune*, the *Wall Street Journal*, *Good Housekeeping*, *Yankee;* and also for radio and television coverage. The media exposure, incidentally, more than vindicated the cost of the assembly effort, since it helped substantially to lift Underwood's sales.

It quickly became clear that the materials most in need of conservation were photographic. There were particular problems involved with this material, as the chemicals used at the turn of the century could be unstable, to say the least. The knowledge of conservation technology was limited to very few, and the availability of their time over the long period needed for this work presented further problems. I had complicated this situation by requiring one copy of each negative and positive for study purposes and by establishing the rule that no original work could leave the climate-controlled room without my personal approval.

To display the photographic material, we built an exhibition gallery at our new headquarters on Route 128, employed Mr. William Bagnall as curator, and set a schedule of four to six exhibitions per year, to which the Westwood town citizens were regularly invited. Other exhibitions were held at our plant locations, and Mr. Bagnall produced many eclectic exhibitions, typically with an educational element, a local slant, and a reflection of company activities.

In the process he ran across the company's holdings of Loring's and Lyman's material and also learned of additional documentary material and artifacts held by the Underwood family. They had always been understandably reluctant to court publicity, but Mr. Bagnall was able to persuade some holders of material to support an exhibition in the company's gallery. Not only was this a success locally, but it opened the eyes of a broader and more professional group of photography experts, collectors, and historians to the work of the Underwood brothers.

In the meantime I had made inquiry of museum sources for a person of experience, skill, and the patience required to maintain these qualities over the months necessary to deal with so many pieces. Robert Lyons undertook the work and, while performing professionally in the matter, more or less fell in love with the material.

So we came full cycle nearly a century later, as the company once run by Henry again provided the resources to support the work of his two talented brothers.

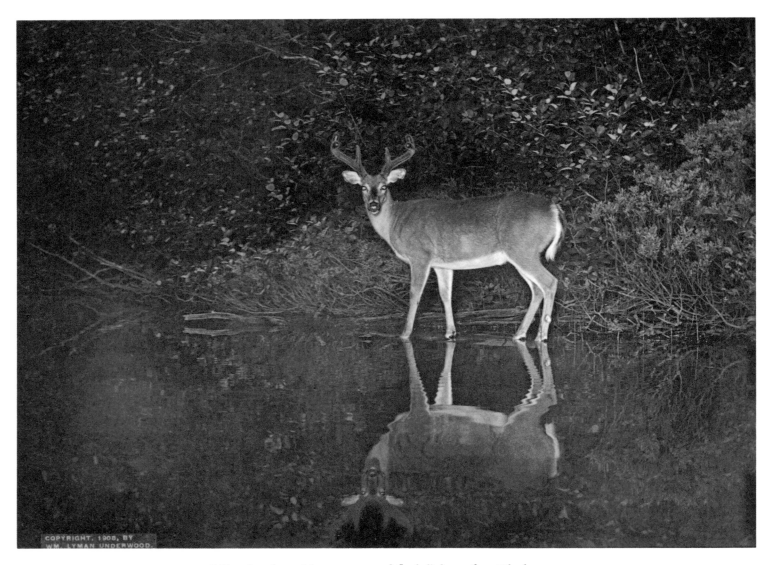

COPYRIGHT, 1908, BY
WM. LYMAN UNDERWOOD.

"*Shooting deer with a camera and flash-light outfit – The hunter seldom catches so beautiful a pose as this.*"
Wm. Lyman Underwood

PRESERVING THE LIGHT

The Photography of Wm. Lyman Underwood and Loring Underwood

CAROL SHLOSS

I

On November 6, 1899, Wm. Lyman wrote a hasty letter to his younger brother, Loring, who was traveling in Europe with his new wife. The letter catches the two young men in the circumstances that would define their lives and influence the photographs that have become their most lasting heritage. "Everything is going on as usual at home and here in the office," he assured Loring as he went on to describe his plans for the winter: he would begin to lecture on "Hunting with the Camera," he would write an article on "Science Applied to the Canning Industry," and, if he had time, he would contribute animal photographs to the U.S. Forestry's exhibit at the Paris Exposition, lecture on food preservation at the Massachusetts Institute of Technology, and continue to work for the family business, the Wm. Underwood Company. He closed the letter with an apology for his spelling and by enclosing a laundry bill "which no doubt belongs to you." Wm. Lyman was always scrupulously fair.

There is an infectious enthusiasm to this letter, and, to those who read it in retrospect, a sadness. Within a year Loring would be back from Europe and he and Wm. Lyman would have to face the fact that life "as usual" in the office would not go on in the way that they had both expected. Instead of providing a focus for the collective efforts of the three brothers, the company would henceforth be run solely by Henry Oliver, the oldest son who was already its president and treasurer.

To Wm. Lyman, who had been actively working with Henry in the canning industry since 1880, the blow came hardest. He believed that family members should "pull together", and it was only through his belief in life's ultimate balance that he was able to maintain any equanimity in the face of his brother's domination. On March 2, 1900, when he wrote to Loring again, his tone had changed considerably:

I agree with you it is best not to discuss with Henry about our affairs; it only makes him harder to get on with. He is suspicious of everything and puts a wrong construction on everything we do. . . . Of course we must try to put ourselves in Harry's place and try to look at the matter from his standpoint. I have ever believed that in the world every man, woman, or child will get in the end just what through their conduct they are entitled to and justice will prevail.

Did I not have this feeling my existence for a number of years would have been a hell on earth.

He was fair in large matters as well as small ones, but his anguish is unmistakable. Loring, younger, educated at Harvard, with a clearer sense of his own alternative interests, was probably less affected by Henry's desire to exclude them. It was decided that William Underwood's two younger sons would remain on the board of directors and that they would receive private incomes.

From this point, all three brothers faced life from the positions that would, in some ways, define their subsequent life choices: Henry remained firmly and exclusively within the business community, his own destiny aligned with the fate of the canning industry. In Report IX, Harvard Record of the Class of 1879, he considered his most remarkable achievement that he had never missed a day of work from illness since he left college. Wm. Lyman and Loring had, of course, the more complicated fates: financially secure, dependent upon the family industry and yet personally estranged from it, they held the privileges of class

without maintaining the allegiances that often accompanied it. In some ways they entered the new century in America with the opportunity to be "new" along with it. Although Wm. Lyman could not then have known it, his letter to Loring in 1899 was a portent of both their futures: Loring was abroad because he was touring European gardens and because he was going to study with Edouard André at the École d'Horticulture in Paris. He would become one of the first professional landscape architects that America produced, spending his life mediating between the natural and urban industrial worlds. Wm. Lyman had no such specialized training to fall back on, and it was only gradually that he recognized the importance of his own private leanings. He, as well as Loring, was concerned with the preservation of America's natural heritage, and though he initially thought of his "Hunting with the Camera" talks as entertainments got up for his friends, he came to see that, in following his own penchant for life in the woods, he could not only provide an alternative career for himself as a lecturer, but also shape the attitudes of a generation of Americans who needed to curb their impulses to kill if whole species of animals were to survive. In a letter written to Albert LeBreton on December 7, 1899, he explained his rationale: "I do it for the fun of the thing and with a view to foster a better feeling among sportsmen against going into the woods merely for the sake of killing game or catching fish. The rod and gun are all right, but we must use moderation or there will be nothing left for our future generations to hunt after except money."

In a sense one could say that Wm. Lyman and Loring pitted their own schemes of preservation against the alternative kind of preservation practiced by the Underwood Company, chal-lenging through their career choices the very industry that provided the underpinnings of their own prosperity. Not that they undermined Henry or the business in any direct way, for they clearly did not. Wm. Lyman continued to lecture on can-ning processes at M. I. T. for many years, and in 1922, at Henry's death, Loring assumed the presidency of the company. But in choosing to become involved in issues of land and wildlife management, the Underwoods joined in one of the central dramas enacted in America at the beginning of the twentieth century: the battle between the proponents of unfettered indus-trial expansion and those who understood that continued commodification of America's natural resources would end in the devastation of the continent. Wm. Lyman's and Loring's photographs are, consequently, records of a world balanced between the virtues of wilderness life and those of urban indus-trialism. They are images that collectively name a middle ground between the civilized and the savage, the formal and the natural. Each spring of his adult life, Wm. Lyman faithfully journeyed to the peace of northern Maine. Loring, always less extreme than Wm. Lyman in his solutions, saw the garden as an antidote to society: "Ah! These hours spent in the garden; they are glorious for all alike. We become children again, playing idly with some freshly picked flowers. . . . Who cares for business, politics or the whirl of society in such times as these? It is enough to be alive in the midst of such heavenly things."

Despite their various retreats from society, both brothers must have known that business and politics provided the background against which their own ventures into nature assumed meaning. Joining many others of their generation, they aspired toward nature in proportion to its decreasing role in American life.

II

The business that was always in the background of Wm. Lyman and Loring's lives was, of course, the Wm. Underwood Company. Established in Boston in 1825, it was originally a con-diment manufacturer. William Underwood had learned his trade in London, where he was apprenticed in Mackey & Company, a firm which pickled foods with fruits and spices from various parts of the British Empire. Underwood had been enterprising and astute, for he learned not only from the exper-

tise of Mackey & Company, but also from the experiences of Nicholas Appert, a French scientist who had won an award offered by Napoleon to anyone who could devise a portable ration in nonperishable form for his armies. In 1809 Appert discovered a process of sterilization which kept perishable foods fresh for indefinite periods of time. With only this specialized knowledge, Underwood had emigrated to the United States, beginning his business there with mustards and berries. In 1828 he began shipping preserved milk to South America, and in 1835 he expanded his products to include canned tomatoes. In 1839 Mr. Underwood conceived the idea of using a tin canister as a less expensive and more adaptable form of container; five years later, he established a lobster cannery at Harpswell, Maine, and in 1850 he packed New Brunswick and Prince Edward Island oysters at the Boston plant. It was during this period that he began packing salmon in tin cans, and history records that the first gold that came East from the California mines was concealed in one of Underwood's salmon cans. At the time when Wm. Lyman joined the firm in 1880, the Underwoods had just completed a large, modern plant in West Jonesport, Maine, where they canned sardines and processed clams, lobsters, and other fish products. Shortly thereafter they opened a similar cannery at South West Harbor on Mount Desert Island.

The largest boost to the family enterprises came during the Civil War, when the U.S. government asked the Underwoods to supply the Union Army with canned tomatoes, roast beef, pickles, and canned milk. It was during this time that the Underwood trademark item, deviled ham, was added to this list, and during the Spanish American War, it was this product that the U.S. government once again requested for its troops. There is no doubt that times of war provided the Underwoods with the greatest spurs to their personal prosperity.

The red devil insignia that identified the ham eventually came to emblemize the family's entire line of preserved goods. Originally it was a leering, truly demonic creature with horns, barbed tail, and pitchfork, who dipped a whole ham hock into his burning cauldron. The image identified both the spiciness of the food and the heat/sterilization process which preserved it, but in an odd way it came to symbolize more than the Underwoods

could ever have intended. Certainly there was something demonic behind the displacements of culture that the existence and extensive use of canned goods implied. Just as in Napoleon's time, these tinned products were most needed in situations of aggression or conquest where a continuous relation to the natural cycle of food production has been disrupted. Owen Wister (one of Henry Oliver's Harvard classmates) acknowledged this when he featured deviled ham as the stock item of the Wyoming cowboys in *The Virginian* (1902). Each day, the protagonist, an Eastern tenderfoot, would watch them gear up:

Morning had been for some while astir in Medicine Bow before I left my quilts. The new day and its doings began around me in the store, chiefly at the grocery counter. Drygoods were not in great request. The early rising cow-boys were off again to their work; and those to whom their night's holiday had left any dollars were spending these for tobacco, or cartridges, or canned provisions for the journey to their distant camps. Sardines were called for, and potted chicken and devilled ham; a sophisticated nourishment, at first sight, for these sons of the sage-brush. But portable ready-made food plays of necessity a great part in the opening of a new country. These picnic pots and cans were the first of her trophies that Civilization dropped upon Wyoming's virgin soil. The cow-boy is now gone to worlds invisible; the wind has blown away the white ashes of his campfires; but the empty sardine box lies rusting over the face of the Western earth.

So through my eyes half closed I watched the sale of these tins, and grew familiar with the ham's inevitable trade-mark — that label with the devil and his horns and hoofs and tail very pronounced, all colored a sultry prodigious scarlet. And when each horseman had made his purchase, he would trail his spurs over the floor, and presently the sound of his horse's hoofs would be the last of him.

Wister's reason for using this detail was not incidental. To him, the litter of the tin cans was only the prelude to the industrialization that would eventually conquer the wilderness, turning the land from an untrammeled expanse into resources which would need a complicated plan of management if they were to survive at all. Wister represented in fiction what others were beginning to recognize in fact: private industry could not continue to use up the natural world without some kind of foresight or restraint.

Wister's novel posed the American West between sagebrush heroism and the sale and distribution of factory goods, between cactuses and commodities. It played out a drama of ownership, depletion, and attempted salvation that Theodore Roosevelt identified in his famous Inland Waterways Commission speech of 1908 as "the weightiest . . . now before the nation." "The national resources of our country," he said, "are in danger of exhaustion if we permit the old wasteful methods of exploiting them longer to continue."

III

When Wm. Lyman severed his relations with the Wm. Underwood Company, he left far more than a difficult older brother. His nature studies and his photographic work in some ways exist in implicit dialogue with the factory system and with the values represented by it. The photographs that eventually illustrated his life as a public lecturer offer up a vision of a new or at least a redefined relation to the land and to the animals that industrialism saw only in terms of profit.

It is important to say that Wm. Lyman would never have thought of his own efforts in this light – at least not at first. He remained involved in the canning industry through his research and publications, and, in fact, when histories of the Underwood Company are written, it is usually Wm. Lyman who is thought to be the more noteworthy brother, for it was he, rather than Henry Oliver, who "saved" the business at a crucial juncture by discovering why canned goods soured or spoiled. Samuel Prescott, in 1895 an assistant in the Department of Biology and later dean of science at M.I.T., remembered meeting him in the 1890s:

The first time I saw him was when he came into the M.I.T. laboratory and said he wanted to help solve the microbe problem that was crippling the young canning industry. He wanted to find the microbe that was threatening to ruin his family's business, but he didn't know what a microbe looked like. Well, it seemed ridiculous. But there was something about the husky little fellow that impressed you . . . and there was also the fact that he was miserably unhappy in the business end of his family's project. So even though he had all the surface appearances of a young man looking for a place to fail, I told him to come to the M.I.T. laboratory every afternoon prepared to work hard. He did, too. He'd arrive at the stroke of four and he was content to sit for hours watching the development of a single experiment and enjoyed every second of it. He learned amazingly fast. In a year I found I had a partner where a short time before I had a student. Together we worked out time and temperature controls for sterilization and canning that are now in use throughout the world.

On February 8, 1898, the two men presented a paper entitled "Science and Experiment in the Canning Industry" to the Atlantic States Packers Association at Buffalo, New York. By 1899, Wm. Lyman had acquired the beginnings of an independent reputation in industrial research: he had been asked to write "Early History of the Canning Industry" for the *American Grocer* and another essay on the new Underwood sardine factory in Jonesport, Maine, for *Technology Quarterly*, a scientific magazine published by M.I.T. Henry Oliver objected both to the idea of publication and to specific assertions within the essays – which did nothing to ameliorate family tensions. Eventually it was clear that change was in everyone's best interest, and Wm. Lyman found himself, at thirty-five, with a life to shape outside of the industry that had absorbed so much of his previous time and effort.

Part of his dilemma was solved by the logic of his own earlier endeavors: in 1898 M.I.T. had asked him to lecture on specific subjects – including the canning industry – and they continued to list him as part of the faculty until 1928, the year before his death. But the university did not provide a total solution to his new status outside the business community, and it took some time before Wm. Lyman began to recognize the full value of

what he had hitherto regarded as an avocation: his activities as a naturalist photographer.

It is not clear how lecturing for pleasure turned to lecturing as a professional endeavor, but by March 1901 he had engaged McCaulley Smith, formerly a colleague of James Burton Pond, as his agent. Before meeting Wm. Lyman, Smith had worked primarily with musicians, while Pond, a more versatile agent, had been the most successful lecture manager in America in the years following the Civil War. It was an era bent upon self-improvement, and Pond had no trouble filling auditoriums with Americans bent on hearing Mark Twain, Walt Whitman, Susan B. Anthony, Julia Ward Howe, Frederick Douglass, and Booker T. Washington. Among these noted speakers, those who specialized in natural history formed a distinctive subgroup, and Pond, looking back at his career among distinguished people, remembered Ernest Seton-Thompson as the most popular of all those who were actively engaged in platform work in 1900–1901. Frank Chapman, whom Wm. Lyman knew through his work at the American Museum of Natural History and through his photography of birds, credited Seton-Thompson with making natural history widely popular among the public through his collection of animal stories, *Wild Animals I Have Known* (1898) and *The Biography of a Grizzly Bear* (1900).

In retrospect, we can see how events conspired to bring Wm. Lyman to an equivalent position among photographers, for if he had been working with the family firm since 1880, he had also been photographing for an equal time, using the camera that his uncle, George Latham Underwood, had recommended for his enjoyment when he was a boy. He used it at home and took it with him when exploring the Maine woods became his private passion. In 1890 he made his first fishing trip to the lakes at the head of the St. Croix River, and from this point his life was never without the extensive yearly retreats – to Maine, Florida, Wyoming, and California – that were finally recorded in his book, *Wilderness Adventures* (1927).

Increasingly the sportsman's life – its proper conduct, its pleasures, its meaning in a larger, cultural context – absorbed him. In 1889 he joined the Massachusetts Sportsman's Association; ten years later, in 1899, he joined the New England Sports-

man's Association; the year following, he became a lifetime member of the League of American Sportsmen. Whatever his initial motivation in joining these groups, his own interest rather quickly grew into gathering photographic trophies rather than dead animals. Years later he could see that he had been at the forefront of a national movement of sportsmen who understood that all sport would cease unless Americans could curb their unrestrained slaughter of wildlife. If the Puritans had contributed to an ideology of natural conquest, seeing the wilderness and the animals within it as obstacles to founding God's "city on a hill" on the new American continent, then Wm. Lyman abandoned that ideology, and in fact contributed to reversing it. As the Maine woods became more and more familiar to him, he joined Emerson and Thoreau in seeing the natural world's goodness and in convincing Americans that the Indians, the animals, the trees themselves had a sacred quality. Not that he advocated the cessation of hunting or lumbering or the end of sardine or lobster fishing, for he accepted these as necessary activities. But he saw them in a perspective that was undistorted by greed and softened by a natural sympathy for creatures untamed by the restrictions of civilized life.

In 1898 he made his first major investment in north woods life: he bought land to the southwest of a Maine sportsmen's club in Lakeville Plantation. His own cabin was furnished primitively, and it was intended for private vacationing rather than sustained and independent living. His family and friends continued to eat their meals at Duck Lake Lodge while Wm. Lyman, along with Joe Mell, the Indian guide who became his lifelong companion, stalked the woods and canoed through the lakes and rivers of New Brunswick. At the time all nonresident hunters in Maine were required to go out with some kind of guide, a measure designed to prevent forest fires and other accidents; but Wm. Lyman achieved a particularly close relation to his Passamaquoddy friend, seeing in him an example of what men could be if they remained close to nature. Joe was an astute reader of natural signs, an interpreter of animal movements and habits, a namer of birds, a survivor who knew how to build canoes and shelters from natural materials and how to supply fish and game for meals. Wm. Lyman treated him with the unwitting condescen-

sion of an upper middle-class man who assumed servants to be his natural right, and also with the respect due to someone with a wealth of skill and natural dignity.

Years after their first excursions together, when Wm. Lyman lectured on "Journeys with an Indian," he summarized Joe's character by saying that he was a "gentleman by nature," for he had intelligence and pride even when it was not aligned with the conventional middle-class trappings of clothing and furniture. If Henry Oliver had played a blocking role in Wm. Lyman's life, then certainly Joe played the emblematic role of liberator.

In 1927, when Wm. Lyman collected his various lecture and photographic materials in *Wilderness Adventures*, he framed the book – first and last chapters – with accounts of his adventures with Joe Mell. In the first, it is Wm. Lyman who plays the tender-foot part – the bouyant but ignorant dweller in the woods that are familiar to Joe – but in the last, when Joe comes to Boston and New York, their roles are reversed so that Joe plays the buffoon, unable to "read" the signs of city life that Wm. Lyman (and his audience) take so much for granted.

In telling of Joe's responses to the urban world, Wm. Lyman had found a way of leveling some of the charges against "civilization" that he could not express directly: "Joe's Indian friends had told him that if he ever went to a city he would be arrested immediately. Jail was the Indian's idea of civilization." Although Wm. Lyman was quick to reassure Joe that this was a false perception, the city did remain something of a prison for the Indian who could not distinguish one granite building from another nor find his way along the grid of perpendicular streets. The "rock" of the sidewalks and the lack of soil or greenery depressed him so that the "miracles" of modern construction – the bridges, the tunnels through mountains or under water, the elevators up into the height of skyscrapers – never succeeded in compensating him for the loss of connection to himself or to the land. "This is awful place; people going and coming all time. . . . I awful glad when I get back my canoe and my paddle." When Wm. Lyman took Joe to Boston's North Station to return, "with a joyous heart," to the sparsely populated north woods, he idealized that return: Maine became for him an almost mythic place which offered both freedom of spirit and escape from the noise and oppression of the city. Joining Joe each spring and fall became a ritualistic release, a return to origins and to a world which industrial capitalism was rendering increasingly distant and strange. It was, as I think Wm. Lyman knew, a world at risk, for none of the skills that Joe possessed could survive the "progress" of the Eastern Establishment, which reared industries like the Underwood Company and erected steel and granite buildings in the name of civilization. There is a strongly elegiac tone to much of his writing about the woods.

And yet he also wrote and photographed with the conviction that "progress" could be stayed or impeded, that the uncivilized world could be recognized, valued, and protected. When Wm. Lyman came, finally, to document his wilderness experiences with photographs and to present them as slides on the lecture circuit, he was, in a sense, acting as a mediator for audiences who could not properly value the natural world because they did not know what it was like.

He is reported to have been a hearty and genial speaker, some-one attuned both to the special qualities of his subjects and to the temperament of his audiences. In his lifetime, he was often compared to Ernest Seton-Thompson and placed in the company of other wildlife photographers and natural historians: Frank Chapman, Raymond Ditmars, A. Radclyffe Dugmore, William T. Hornaday, Martin Johnson, and George Shiras 3rd were all of them "camera sportsmen" who could be considered his peers.

The January 1900 issue of *National Sportsman* describes him as one "whose reputation as a camera hunter is well known throughout the country." "It was he who originated the lectures on 'Hunting with a Camera' which proved to be one of the most interesting lectures ever given before the public. He is the owner of the finest photographs in the country. . . . Mr. Underwood is a true sportsman and enjoys hunting with the camera fully as much as with the rifle." The *Cambridge Chronicle* of April 13, 1901, when announcing Wm. Lyman's forthcoming "Hunting with a Camera" lecture on April 17, stated that "the lecture exceeds in interest those of Seton-Thompson in the same line, which is great praise." Later, on April 20, the *Chronicle* said in review, "Mr. Underwood has been compared to Seton-Thompson, the renowned lecturer on animals and birds. While his 'repertory'

is not as large, and his experiences comparatively limited beside those of Seton-Thompson, his range of investigation has been quite extended for an amateur, and his ability to entertain is quite as marked." Rarely did he fail to please: "The lecture was made still more interesting by the large number, the great variety, and the beauty of the stereopticon pictures." The photographs are "extremely clear and . . . remarkable for their beautiful colors, especially those of bits of scenery, streams, wild flowers, and the like."

As it became clear to Wm. Lyman that his future and his sense of private mission lay in the direction of nature photography, other aspects of his life shifted. He had once been an avid member of the Postal Photographers Club, not only exchanging photo albums with others but organizing the first Boston exhibit of members' work (June 1898). In 1899 he withdrew from the club, sensing, I think, that its amateur status no longer accorded with his own more serious goals. He also began to "protect" his images, and he did this in the midst of rising acclaim. In 1898 he declined to exhibit in the Photographic Exhibit at the Masonic Fair as well as the Sportsman's Exhibition; in 1899 he declined to have photographs in either *Pets and Animals* or *Shooting and Fishing Magazine*. He wanted, he said in reply to all these requests, to save the pictures for some kind of publication of his own.

In these pivotal years he began to invest in better equipment, ordering lenses from C. P. Goertz in New York City, canvas backdrops for animal photos, and new, more convenient cameras: he began to use a 5 by 7 inch Graphic Camera and a 3¼ by 4½ inch pocket Kodak. In retrospect it is clear to us that Wm. Lyman's generation of wildlife photographers existed in large part because an advanced technology allowed it to exist: he could work with dry plates with increased sensitivity to light; high-speed shutters capable of stopping rapid movement; miniature, hand-held cameras; and magnesium flash powder as the first effective source of artificial illumination. He himself engineered a pivotal mount for holding a camera and a jacklamp in the bow of a canoe, and it was with this device that he captured many of his most famous pictures of startled deer and moose in their natural habitat at night. Night hunting excited him:

My muscles were tense as I opened the lamp and the beam of light cut a lane through the darkness ahead. There, facing us, stood a young doe drinking. Closer and closer we crept, until the deer was only a canoe length away. The excitement was almost overpowering. Suddenly I pulled the flash string, and blinding light burst forth from the bow of the canoe and for an instant turned night into day. After the glare, the doe leaped into the air, hit the water, and rushed snorting into the woods.

He began to call these photographs "trophies" and to fit them into a scheme of conduct as well as a system of values: if others would shoot with a camera instead of the gun – if they would follow his example – they could satisfy their predatory inclinations without destroying animals. An editorial from the *Boston Transcript* (May 31, 1909) confronted the issues then at stake in substituting photography for an older hunting ethos. It juxtaposed two photographs – one from *Scribner's* with Theodore Roosevelt "perched upon a departed elephant" and another from *Country Life in America* by Wm. Lyman "depicting a startled fawn, shot by a drop-shutter."

At first, the clerk argued that the gory side of hunting would survive, that it represented a primal passion, and that potting game with Kodaks would never become a sport for the sporty. He had to back down, though. The optimist argued that an astonishing change of sentiment had already taken place. Once you could surround yourself with the corpses of fifty deer or a hundred Dicky birds, pose for your picture, and see it half-toned in Outing *to the glory of your name. You can do the same thing now; only* Outing *will print beneath it, "Behold this disgusting game hog!"*

Again, as the optimist pointed out, slaughter has lost more than half its boast of skill. With the improved modern weapon, almost any gory fellow can slay his thousands and ten thousands with the rifle of an ass, whereas it takes infinite art to steal upon the shy forest creatures and snap their pictures. Finally there's the matter of trophies. The blood-thirsty hunter fetches home nothing but skins. The animal photographer fills whole albums with portraits of living animals, which attest his nerve and coolness and ingenuity and patience.

Still, the clerk would not discount the educational value of Mr. Roosevelt's elephant. It is a surprising object with a tail at each end,

and much larger than we might have fancied. Science should be grateful for so novel a revelation.

In the end, I think it is fair to say that Roosevelt and Wm. Lyman were in the same political camp, for Roosevelt became one of America's earliest and most effective leaders in wilderness conservation. But the editorial served well to show the nature of the oppositions that confronted Wm. Lyman when he chose to be a photographer and to make records not of something lost, but of something preserved from extinction through the "sublimation" of film and flash powder.

As Wm. Lyman grew in his commitments the purpose of his travels changed as well. Once his wanderings were for pleasure, with photographs as incidental mementos. Increasingly it was as if he went places on assignment because he needed to make photographs of a particular subject. Certainly his lumber camp pictures were made in this way: Wm. Lyman went to Morrison Cove, Maine, in 1901 and 1903 in order to prepare for a series of lectures to be delivered at M.I.T. in January, March, and April of 1904. This series, as a whole, is a documentary of the sort Margaret Bourke-White later made famous in *Life* magazine. It shows a sequence of activities throughout the year: 1) "Cruising for Timber: The Felling and Peeling of Hemlock in the Summer Time," 2) "Logging in the Fall and Winter," and 3) "The River Driving of the Logs in the Spring." The intention is to show students the confluence of nature and human industry.

It was during a winter visit to the lumber camps that Wm. Lyman first heard of Bruno, the bear cub who was being raised as a human infant. This story, above all others he told on the lecture circuit, made him famous in his lifetime. It shows most fully the peculiar nature of his genius and the almost childlike curiosity with which he approached wild creatures and wished to communicate with them.

We know from many of Wm. Lyman's letters, photographs, and stories that he avidly loved pets of any variety. Some of his first published photographs – those appearing in the May, September, November, and December 1899 issues of *Photo Era* – were of white kittens, "dainty ducks," and "greedy gobblers." They were all images that placed the animals in a domestic context. In 1897 he wrote a short essay about three young gray squirrels which he kept in a cage in the backyard; two years later he wrote a letter saying, "I have two coons and two foxes living together in a big cage and I want to get a young bear this spring." The bear did not materialize immediately, but by 1900 he had progressed to having a wildcat in residence.

So it was not entirely surprising that Wm. Lyman was alert and receptive to the tale, overheard first at a north woods railroad station, of a cub whose mother had been killed by hunters. His inquiries were soon answered by an invitation to visit the bear in February 1903. At Gordon's Camp, he found a scene that both astounded and moved him: a logger's wife, Effie Beals, touched by the plight of the orphaned animal, had taken him to her breast along with her own baby. If Wm. Lyman's previous inclinations had been to domesticate the wild, he found the apotheosis of his leanings in the "Weldon" (Beals) household: he entered a scene where wife, husband, and children had accepted the black, squirrel-sized creature into their daily lives with extraordinary naturalness. "'Bruno is hungry, mother,' said one of the children. 'Will you excuse me, Mr. Underwood?' the mother asked as she took the little creature from its bed. 'He's real hungry and I haven't fed him since noon.' As he felt the warm hands of his benefactress about him, there came a comfortable soothing tone in the little creature's complaining. . . . the simplicity of it all."

And yet Wm. Lyman must have known that it was not a simple matter at all. Although he told the story in lecture after lecture for many years as a tale of "human kindness and compassion," it was a much more far-reaching drama in its implications – both for the human actors involved and for the animal who bore the brunt of Wm. Lyman's preconceptions about the relation between taming wild animals and an urban, domestic ideal.

When Bruno became large enough to threaten Mrs. Beals's children, she agreed to sell him to Wm. Lyman, who carried him back to Belmont, Massachusetts with a nursing bottle of condensed milk and a dog collar. He understood his effort to be in some way a reversal of a mythic pattern that connected "the lives of the lower animals with those of human beings":

Ancient history gives us the story of Romulus and Remus, the founders of Rome, who, it is said, as infants, were left in the desert to

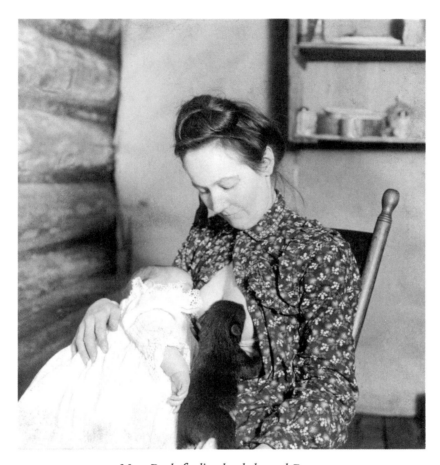

Mrs. Beals feeding her baby and Bruno

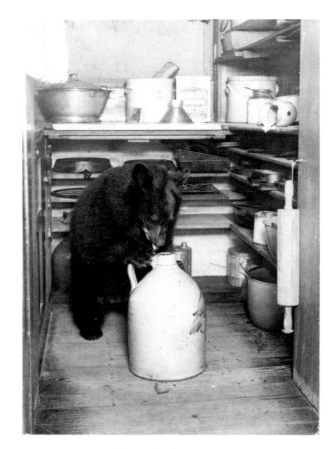

Bruno in the pantry

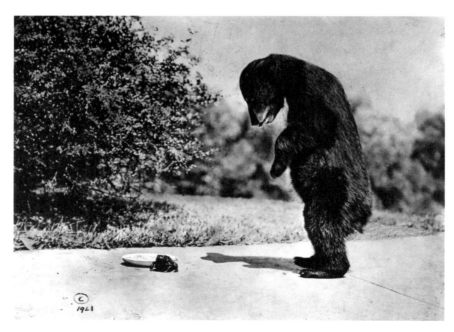

Bruno and toad

starve, and were saved from that tragic end by a she-wolf, which nursed them to vigorous health with her own young.

Greek mythology gives us the touching story of Atalanta, daughter of Iasius, who was abandoned and left to die in the wilderness. She, too, was saved by one of the lower animals, for a bear nursed her and brought her up with its cubs.

Kipling in his Jungle Book *has immortalized Mowgli, the man's cub, who fled from the wrath of Shere Khan, the tiger, and took shelter in the den of a wolf, and was brought up with her young.*

Having established the mythic kindness of wild animals to various hapless human children, Wm. Lyman pointed out to his audience that Bruno was unique in encountering human beings with a commensurate maternal instinct. In telling the bear's story, he emphasized the bonds of empathy that bound everyone to Bruno, but it is difficult to see what really motivated him to include a bear in his own household. He performed no systematic experiments or training; he did not try to communicate with it or to integrate it into the human community. In both the lectures and the book which summarizes these experiences, the bear figures primarily as the originator of amusing anecdotes: Bruno loved to eat from the honey barrel; Bruno loved to play football with a dog named Foxy; Bruno could sit in velvet chairs in the parlor seeming to wait for tea; Bruno warmed his bottom in winter by climbing into the family washtub. For the lecture circuit, these mischievous adventures provided marvelous material. My favorite story is of Bruno's encounter with a toad:

Owing to his unusual bringing up, Bruno had never become acquainted with the ordinary animals of the woods and fields, and so I was curious to see what he would do when he met any of them. Down in the garden one day I found a large fat toad, and when Bruno was at lunch I placed the warty creature on the ground beside the saucer from which the cub was taking his food. Being quite hungry, at first he paid no attention to the intruder; but presently, as the saucer became empty, he caught sight of his curious visitor. With a jerk he raised his head and for a moment, without moving a muscle, gazed in astonishment and with some misgiving at the strange monstrosity in front of him. His natural curiosity, however, soon overcame his doubtful frame of mind; he was a born investigator and this thing

must be looked into. . . . [The toad] hopped, and with such force that it went quite over the saucer. Simultaneously the bear stood erect. He had a puzzled look of amazement and dismay on his hairy visage; he appeared to be utterly overcome with astonishment.

It was only when Bruno weighed 200 pounds and insisted on dancing with Wm. Lyman in a strangling embrace that his wife, "Comrade," suggested, tentatively, that she would rather have a live husband than a pet bear who knew the foxtrot. Bruno went to the zoo.

Years later, in 1921, when Wm. Lyman wrote a book about Bruno, he called it *Wild Brother* – a title with a curious resonance considering the substance of the narrative. For "wild brother" was, of course, the name of the timber wolf that figured so prominently in Jack London's *The Call of the Wild*, which was published in 1903 – the year that Wm. Lyman found Bruno in the woods.

But where London's wild brother is the lean, untamed creature who howled to John Thornton's dog, Buck, making him realize the fierce instinctual life that raged beneath his obedience to man, Bruno is portrayed first as a yelping cub whose little cries resemble a human baby's and then as a clumsy prankster who is frightened of a toad. London's dog wanders farther and farther from civilization, finally realizing his destiny in running with a wolf pack: "The blood-longing became stronger than ever before. He was a killer, a thing that preyed, living on the things that lived, unaided, alone, by virtue of his own strength and prowess, surviving triumphantly in a hostile environment where only the strong survived." In contrast, Bruno eats raisins and lives in a cage with an underground nest. "His parlor tricks were rough and boisterous, his free-and-easy manners inappropriate. He was like a bull in a china shop. His attitude toward furniture was especially crude; if a Chippendale chair chanced to be in his way, he never walked round it, but went through it or over it."

Not only had Wm. Lyman's experiment with Bruno reversed the mythic pattern of children saved by animal mothers, but it reversed the ethos of wilderness life that Jack London, to take one example, espoused. The basic question underlying Wm. Lyman's raising of Bruno was whether the life of instinct could

be modified or completely subdued by the rules of domestic conduct. In a curious way, Wm. Lyman's project seems to have been to stifle the call of the wild, to tame it, to make it amenable to the upper middle-class life to which he was accustomed and which he unwittingly held up as a universal ideal. In his life, the Joe Mells and the Brunos of the world might "call" one to occasional wilderness experiences, but in the end, they would be defeated, caged, consigned to life on the periphery of a more powerful and professionally organized elite.

Wm. Lyman continued to lecture until a few years before his death on January 28, 1929. "Journeys with an Indian" and "Wild Brother" were but two of the lectures listed in his promotional brochure booklet. The other six topics were "Adventures in the Land of Sunshine," "Strange Characters I Have Known," "Adventures in the Back Woods of New Brunswick," "Adventures of a Sage-Brush Tourist in Wyoming," "Enemies at Home," and "Children of the Woods." Each was compiled after a private journey, usually in the company of his wife and/or a few intimate friends, and each was distilled and modified according to Wm. Lyman's assessment of particular audiences and the time alloted him for speaking.

"The Land of Sunshine" photographs and lectures began after Wm. Lyman's first fishing trip to Florida (1907), where he rented a houseboat and launch to take him and his companions along the lakes, rivers, and shores of the Florida Keys and Lake Okeechobee: "Between the Keys and Cape Sable on the mainland of Florida lies an area of shoal water some two thousand square miles in extent and only a few feet in depth. . . . Gliding, drifting, or darting through the beautiful marine gardens of the reefs and keys swim countless fishes as remarkable as their surroundings. In holes and grottoes of coral formation lurk the big and hungry groupers." Wm. Lyman could be eloquent when he wanted or he could be unwittingly funny: recalling a 1911 trip to a grapefruit plantation at Deep Lake, Florida, he remarked, "We slept soundly nevertheless until nearly daylight when we were awakened by the bellowing of alligators in the cypress swamp."

Between 1907 and 1917, he made five trips to the South, sometimes extending his visits by traveling to Nassau and Bermuda.

He went always as a sportsman/naturalist looking at the wilderness life of birds and fish. He also went with the sensibility of someone trained to see the land as an industrial resource: when he went to Nassau, he took an interest in the sponge industry; in 1911 he made a rather dangerous trip through barely passable swamp land to see a grapefruit plantation near Deep Lake. He was concerned to know about the Florida East Coast Railroad project that would make overland travel to Key West possible. Sporadically he would notice human life in these outposts – about Miller's Ditch, Florida, he said, "The fishermen who lived here were the dirtiest and the worst looking lot of people that I have ever seen. Barefooted children were wallowing about in the mud." But people were usually incidental to his interest in animals unless they were guides or extremely idiosyncratic characters. He was not inclined to analyze human character or to question the assumptions of American social organization.

In 1912 he rode through the Great Lakes on a freighter; in 1913 he traveled to Wyoming; in 1916 he went to California. I think it is correct to say that by the time these trips were made, he had acquired the habit of seeing photographically: where early manuscript records of trips occurred as narratives or as a series of diary entries, the 1913 manuscript about Wyoming is organized around images that could represent the progress of the travelers: "Jupiter Terrace: Extends 200 feet along the highway, 100 feet high. There are 200 acres of formation similar to this in the vicinity of Mammoth. In climbing about I was affected by the altitude, short of breath." These visual habits persisted in the projects he undertook at home in Belmont in his role as a concerned citizen.

All of the Underwoods were raised with the ideal of public service: Henry Oliver was a Belmont town selectman; in 1902 he donated a public library building to the town as a memorial to his father; nine years later, in an effort to prevent the Boston Elevated Company from constructing streetcar tracks in front of his property, he purchased the land and then agreed to build a playground, bathhouse, and swimming pool for the children of the town. Wm. Lyman dedicated himself to the town as well, but in a slightly different way. Where Henry Oliver served in the ways that wealth can serve – by building monuments – Wm.

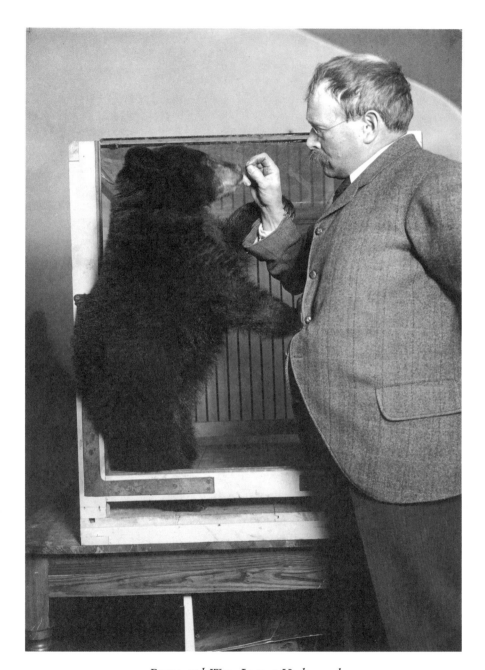

Bruno and Wm. Lyman Underwood

Lyman conceived of his role as an educator, as someone dedicated to the improvement of habits and understanding: when he was appointed chairman of the Belmont Board of Health, the Board of Water Commissioners, and the Board of Park Commissioners, he not only identified problems, but he helped to solve them. During these years, the yards and parks of Belmont were being destroyed by brown tail and gypsy moths. Wm. Lyman undertook a series of illustrated lectures to show the life cycle of these insects so that people could recognize and arrange appropriate ways to exterminate them. In a similar way, he researched the spread of yellow fever and malaria: "Most of the mosquitoes that annoy us have been bred nearby. They are found in our own dooryards or in those of some nearby neighbor. Mosquito wigglers may be found in old tin cans, pools, the rocks, catch basins, rain water barrels, cesspools, old decayed stumps, gutters upon our houses. . . ." On August 3, 1901, the *Boston Transcript* referred to Wm. Lyman's efforts to convert the Fresh Pond marshes into a municipal park: "The entire history and present condition of this territory were gone over very thoroughly a few months ago by Dr. William Lyman Underwood, of the Belmont Board of Health, in a paper printed in the *Technology Quarterly* and illustrated with numerous photographs."

The *Springfield Sunday Republican* of April 6, 1902, contained a detailed article telling how Wm. Lyman raised mosquitoes and used kerosene to destroy the larvae, goldfish to eat them, or an oil spread on the water to suppress them. In 1903, still in pursuit of Fresh Pond drainage, he encountered a mishap: "Much merriment was caused by the fact that the 'gas' (for the stereopticon) gave out about halfway through the lecture, and Mr. Underwood was obliged to furnish sufficient 'gas' (self engendered) to make the absent pictures real, which he was abundantly able to do."

In 1903 he added the common housefly to his list of enemies, showing how it carried typhoid and dysentery: "War upon flies is to follow the vigorous campaign which is being carried on for the extermination of mosquitoes. It has been found that the housefly, like the mosquito, is an active agent in the dissemination of disease. Scientists who have made a study of its habits are able to show that its presence is always a dangerous menace to health." Never one to leave things to imagination, Wm. Lyman offered his audience "photographic proof of the fly's dissemination of germs" by showing a picture of "the housefly in a piece of sponge cake" four times enlarged and another strangely unintelligible image which, we are told, is "footprints of a fly on nutrient beef jelly; every white spot is a colony of millions of microbes." In these ways, he battled for years to improve sanitation in American cities.

On a slightly less militant note, he assembled slides to show the history of Belmont and Nonquitt, Massachusetts, and he gave a presentation speech for his old grade school teacher, Mary Burbank. It was here, in looking backward over the achievements of his own lifetime, that he could joke about his unpromising beginnings – as a boy, he recalled, he could not spell "William" because the Underwoods always nicked it to "Wm."

From 1906 to 1924, Wm. Lyman recorded 773 lectures with notes about his earnings, the size of each audience, and their responses to his performances. Some examples:

25 March 1911/Waverly, Mass./"Journeys in Unfrequented Florida": About 50 present not a very wide awake crowd but they seemed to enjoy it.

28 February 1912/St. George's, Bermuda/"Hunting with Canoe and Camera in the Woods of New Brunswick": The lecture was given in aid of the St. George's Grammar School at the request of Mrs. Capt. Wm. E. Myer. There were about 75 people in the audience. The stereopticon, a single lantern and a very dilapidated affair, was run by an ex–French count, once a gentleman but now through hard drink down and out. He comes to Bermuda every winter to run a moving picture machine, and he happened to have on the island hydrogen and oxygen for the calcium light. His lens, however, was a very poor one and would not fit in the lantern. It had to be held in position by a piece of newspaper. As a consequence the pictures wobbled all over the screen and were much out of focus. However the audience seemed very enthusiastic and thoroughly enjoyed the lecture. I showed the usual pictures, with the addition of the screechowl and frog and the loon pictures."

11 April 1913/Buffalo, N.Y./"Bruno, the Bear that Was Brought Up as a Child": As the street car strike was in progress and no cars were running, the clerk told me it would be quite late in the afternoon before [Mr. Howland] returned, as he would be obliged to walk two miles from his house. . . . After a good dinner . . . I went again to the library and found Mr. Howland. . . . He was much worried, however, about my evening lecture. On account of the strike he feared that I would have a very small audience, not only because there were no cars running but because it was a rainy day . . . I was much surprised and delighted to find . . . nearly 400 people, who had braved the strike and the storm."

The greatest number of lectures he gave in one year was seventy in 1921; the smallest was twenty-two in 1916 and 1918; he averaged forty a year. Over the years, he earned a total of $9283.00, a fact that tells us both that he prospered by virtue of a private income and that he retained his civic-mindedness to the end: he charged what various groups could afford to pay and sometimes spoke for no more than the cost of running the lantern for his slides.

His audiences were varied. Often he addressed local civic groups like the Arlington Women's Club, the Malden Teachers' Association, or the Thursday Evening Club. He lectured to other sportsmen at the Rod and Reel Club, the Pack and Paddle Club, and the Campfire Club of America – an exclusive association whose requirements for membership were "to have camped on the ground in a howling wilderness, and to have killed or painted big game." When he spoke to the Campfire Club for the second time on January 7, 1911, he joined several other guest speakers: J. Alden Loring, whose topic was "Through Africa with Roosevelt," Captain Vincent Gordon Stanhope of the 9th Royal Lancers ("Among the Cannibal Head Hunters"), Roy C. Andrews, naturalist and explorer ("In Pursuit of Whale in Eastern Seas"), and George D. Pratt ("Autochrome Photos on Canadian Trails"). It was on this occasion that Wm. Lyman reminded the club members of their previous generosity in taking up a collection for Mrs. Beals, Bruno's human mother whose family had fallen on hard times. Wm. Lyman ended his lecture with Mr. Beals saying, "My, Mr. Underwood, but wasn't that a great thing. Just think what our kindness to that little cub has meant to us." It was a telling remark, for it placed the Bealses, Wm. Lyman, and his audience in their various social roles: the Bealses as the recipients of charity, and the speaker and the audience acting out a male, WASP sense of beneficence. Many of the clubs to which Wm. Lyman spoke were similarly constituted, prestigious private social clubs, whose members were powerful members of the Eastern Establishment who sought to further their interests by close association with one another. Corporations had learned that their most successful response to industrialization was consolidation; centralized boards of directors made decisions which affected vast sums of capital and huge holdings. Boarding schools, Ivy League universities, and exclusive clubs provided sons and potential sons of the establishment with a precise training in social expertise. All of these institutions recognized the need for a commitment to the new industrial order, whether in the consolidation of business enterprising or in the vast creation of self-perpetuating social elites.

If Wm. Lyman's wilderness experiences and his photographs were unique, it is nonetheless true that when he spoke of them, he usually addressed his social and economic peers – men whose wealth and social position allowed them to take a "kindly interest" in his forays into the woods. He was both idiosyncratic and one of them, a conservationist working at the forefront of a national movement, and the child and brother of familiar industrialists.

These contradictions can account for the nostalgia that Wm. Lyman's images evoke – and evoked, I think, even in his own time. As he spoke to the St. Botolph Club or the Algonquin Club or the Beacon Society, telling them of travels with an Indian or hunting with canoe and camera, his photographic images preserved a world that was vanishing because of the industries that they themselves had gathered together to uphold.

Loring Underwood, the youngest of the Underwood brothers, was more conservative – or at least less flamboyant – than Wm. Lyman. At his death in 1930 at the age of fifty-six, he was remembered for his "genial manner," his "simple friendliness," and "his desire to be helpful without ostentation." In his love of the outdoors, he was kin to Wm. Lyman, but his life fell into more conventional channels. He loved playing Santa Claus, but he would never have raised a pet bear. Even the most innovative feature of his life – his decision to become a landscape architect – was accomplished without any of the sense of crisis that characterized his brother's choice of career. He went to the Noble and Greenbough School for boys in Boston and then to Harvard College (1893–1897). Soon after he graduated he married Emily Walton and in all but his career led the life of an upper middle-class family man. His line-a-day diaries from 1902 to 1906 are filled with domestic details about his wife, the births of daughters, Lorna, Nina Walton, and Esther Mead, and his love of squash, sleighing, pony riding, tennis, dances, and bridge parties. He was an avid amateur thespian. In 1902 he summarized the fifth year of his marriage, saying simply, "Had a very happy year. No disappointments except small ones. . . . More in love than ever." His penchant for domestic life seems to have combined with his love of nature and his training in public service to lead him rather naturally into what was, then, a largely unprecedented career.

In 1897, the year that Loring graduated from Harvard, landscape architecture barely existed as a career, and certainly it did not exist as a formal program of undergraduate study. Charles William Eliot, president of Harvard, was soon to remedy this, and had hoped, in fact, to appoint his son, Charles, as the college's first landscape architecture instructor. Charles's untimely death in March 1897 ended this hope, but a few years later, Frederick Law Olmsted, Jr., nephew of the famed designer of New York's Central Park, was persuaded to begin offering a course of instruction. Looking back on his son's life, President Eliot recalled:

At this time the profession of landscape architecture was hardly recognized in the United States, and there was no regular process of preparing for it. There was no established school for the profession in any American University, and, indeed, not even a single course of instruction which dealt with the art of improving landscape for human use and enjoyment, or with the practical methods of creating and improving gardens, country seats and public parks. The course of instruction at the Bussey Institute did, however, deal both theoretically and practically with several subjects of fundamental importance in the landscape art, and supplied the best preliminary training for the profession which was then accessible; although it offered nothing on the artistic side of large-scale landscape work.

What was true of Charles in 1882 was true also for Loring fifteen years later: anyone with the vision and desire to think about a comprehensive program of land management in the United States before 1900 had to improvise a course of study for himself or herself. Like Charles Eliot, Loring entered the Bussey Institute and was trained not in landscape architecture but in agriculture. The curriculum in 1898–1899 was almost identical to the one established in 1871. (Harvard had acquired the 137 acres of the Bussey Estate in West Roxbury in 1842.) Students were trained in Agricultural Chemistry, Natural History, Horticulture, Agriculture, and Qualitative Analysis. Charles had found the experience "very interesting – quite different from college." To Roland Thaxter he had confided:

We are a class of five, with five instructors – Storer (agricultural chemistry), very interesting; Watson (horticulture), lectures and garden and greenhouse work, also interesting; Slade (applied zoology), anatomy of domestic animals, with dissecting, etc. – pretty dry at present, the subject being bones; Faxon (applied botany) has not appeared yet, but will no doubt be interesting; Burgess (applied entomology) does not begin till the second half year; Motley (farm management), a queer old fellow who lectures and takes us on excursions once a week; Dean (topographical surveying), a course given at Cambridge which only three of us take.

For years, the enrollment at the institute was trifling. As Harvard's president had recognized in his 1871–1872 report, "[There was] as yet, no appreciative demand for thorough instruction in agriculture," but the school was well endowed and it could, he said, afford to bide its time. Looking ahead, he predicted that the institute would become increasingly important: "[T]he cultivation and preservation of forests will become in no long time a matter of national concern. The natural forests of the country are rapidly disappearing, and wood will, at no distant day, be a scarce and dear commodity, as it has long been in many countries of Europe." He could not have known how prophetic his words were. Thirty-six years later, in 1908, Theodore Roosevelt would identify the same drama and predict the same outcome: "The national resources of our country are in danger of exhaustion if we permit the old wasteful methods of exploiting them longer to continue."

When Loring's turn at the institute came, he was part of a class of four. E. R. Cogswell, Jr., A. H. Parker, and H. V. Hubbard, all of the Harvard class of 1897, also attended the Bussey Institute after graduation. Henry Vincent Hubbard, one of Loring's friends, went on to become one of the most prominent landscape architects of his time, beginning his career by joining the Olmsted Brothers' firm in 1900. In 1902 he traveled in Holland, Germany, and France with F. L. Olmsted, Jr. Loring, putting off his apprenticeship, went directly to Europe to travel, to see the classical gardens of the continent, and finally to study with Edouard André at the École d'Horticulture in Paris. He was here, living with Emily and already pursuing the requirements for a professional life, when Wm. Lyman's letter reached him, telling of the crisis with Henry Oliver that proved so decisive in his own move toward a conservationist ethic, the lecture circuit, and the serious pursuit of nature photography.

Loring left no direct record of the studies he pursued under André's guidance, but there is practically nothing he could not have studied that related to gardens. André was known throughout Europe as an expert on both public gardens and private estates, and his book, *L'Art des Jardins*, became a classic reference which guided students through the history of gardens in antiquity to the aesthetic principles that should govern their own

contemporary efforts. André had developed formal systems for the classification of gardens, techniques of surveying, and methods of working with clients, building models, and drawing up contracts. He wrote about water, rocks, grasses, trees, shrubs, flowers, and ornamental foliage; and he considered the construction and placement of garden accessories (bridges, benches, vases, fences, statuary) to be the responsibility of the landscape architect as well.

We know from his subsequent achievements that Loring cared about both the public and the private aspects of his work. When he returned to the United States in 1900, he settled into the estate he had inherited from his parents in Belmont and entered the firm of H. Bailey Alden, where he remained until he set up his own office at 45 Bromfield Street in Boston. The patterns of his professional life were established fairly quickly, for he was both well connected to people who wanted work done on their homes and estates, and part of a family with a strong ideal of community service. He had ample opportunity to exercise his talents in a variety of ways and in a significant context: however unremarkably domestic Loring Underwood's daily routine may have been, it is nonetheless true that he was part of the first generation to professionalize the creation of landscape in America. Frederick Law Olmsted had pioneered in making park systems and relating the use of public space to moral and aesthetic values, but it remained for Loring and his peers to define landscape architecture, to establish professional standards and procedures for it, and to create the educational means for leading promising young men and women into the field.

While Loring was in Europe in 1899, the American Society of Landscape Architecture was being founded in New York. Among the original members were four Bostonians: Frederick Law Olmsted and his nephew, John Charles Olmsted, Arthur A. Shurtleff, and Warner H. Manning. On March 6 they adopted the first constitution, deciding that students could become non-voting (Junior) members, and that Fellows should be at least thirty and have practiced the profession for five years. Loring's friend and classmate, Henry Vincent Hubbard, became a Junior in 1905 and was elected a Fellow in 1910. Loring joined him in 1912. Both men were subsequently instrumental in founding the

Boston chapter of ASLA as soon as the national group authorized the formation of local branches in 1913.

From 1923 to 1925, Loring assumed the chapter presidency. The point is not simply that Loring was a club member but that, as a club member, he placed himself in the midst of a cultural debate of far-reaching consequences. The ASLA went on to establish a quarterly magazine, *Landscape Architecture* (which Henry Vincent Hubbard edited along with Charles Downing Lay). Between lecture topics and written articles we can see the historical perspective in which these men saw their own efforts. Charles Eliot, who had continued to interest himself in the profession long after his son's death, contributed one of the first published articles, "Welfare and Happiness in Works of Landscape Architecture." "What reasons do you give for urging a private person or a public body to employ a landscape architect?" he asked. "By what arguments can the serviceableness of landscape architecture be demonstrated? Are they economic, esthetic, or philanthropic arguments?" Eliot did not dismiss economic motives, and he was careful to identify the profession as a "fine art," but he was clearly most interested in human welfare:

Much sympathy has been expressed in these later years for the unhappy condition of large elements of the population. Much public effort has been made to improve the condition of the less fortunate classes; and among all these efforts there is none more important than the effort to counteract the evils which have arisen from congestion of population. This congestion is a phenomenon of the last fifty years ... this country, following, of course, the introduction of the factory system on a large scale. Now it is already demonstrated that economic considerations alone cannot deal successfully with the actual congestion of population, or remedy the hideous evils which result from congestion. The desires and beliefs of the congested population with regard to happiness, as they understand it, must be taken into account.

In other lectures and articles, the society discussed not only the ideals and motives for its work, but also the whole range of practical issues that faced it: the management of city parks and playgrounds, the development of "high class" minor streets, street traffic, statuary, steps, hardy perennials, good trees and shrubs, and cost keeping systems. In 1916 it was voted that the society adopt a code of ethics. In the same year, it passed resolutions pledging support of a congressional bill to establish a national park service and opposing the erection of a power plant on the banks of the Potomac in Washington, D.C.

Even from these brief excerpts it is possible to see that Loring, in choosing to become a landscape architect, had immersed himself in the obverse side of the issue that concerned Wm. Lyman when he took his camera into the wilderness in an effort to conserve its animal population. Like Wm. Lyman, Loring invested the natural world with moral values, so that its presence or absence from urban life implied something about the health and emotional well-being of the entire social order. From the beginning, the professionals of Loring's class understood the shaping of space to be an act of social consequence; and as both the urban world and America's remaining wilderness areas became increasingly beleaguered, the efforts to mediate between them, to provide openness, light, and natural beauty to densely populated areas, became increasingly self-conscious and urgent.

Loring's own public-spirited efforts as a landscape architect began in Belmont. In 1903 he agreed to act as parks commissioner and he set about his work immediately. The following year he began to plan plantings for the town playground, and during subsequent years he planned the Claypit Pond Park, the Stone Road, the Belmont Hill Company subdivisions, the Belmont World War I memorial, and the pool that his brother, Henry Oliver, had donated to the children of the town.

In 1909 he was commissioned to design a small park for the Mother Church of Christ, Scientist, in Boston. The church had purchased, and toppled, a block of rowhouses in order to open the central basilica to view along Massachusetts Avenue. Loring handled the assignment modestly, relying largely on open lawn punctuated by deciduous trees and shrubs, to convey a peaceful alternative to the clutter of brick that lined the street. He took on work of a much more substantial nature when he accepted the position of landscape architect for Vassar College in 1915. The college was "noted for its grounds and landscaping; in addition to nine separate arboretums, there were two lakes, a golf course, the Dutchess County Outdoor Laboratory and a

college farm." Loring built an amphitheater for commencement exercises and outdoor performances, and he planned a trellised Shakespeare Garden, planted with seeds from Shakespeare's own garden in Stratford, which was to offer the students a place for outdoor contemplation. Following his own personal philosophy that gardens were to be "lived in," he included seats and a bridge. His less dramatic work was equally important, for he looked at lots, sidewalks, street trees, walls, hedges, and lake fronts, offering proposals for their long-term upkeep and suggesting possible sources of revenue. "Possibly money spent in tree planting, gardens and flowers, which will give daily lessons to those living amidst such environment will provide instruction as valuable in realizing the highest ideals in better living, as any given in the classroom."

Despite these achievements, Loring's real passion was for the small, private garden and for the yard as an outdoor extension of the house: "Anyone who has made a study of gardens knows that it was a characteristic of the best of the old New England gardens that they were designed to be lived in, not merely to be looked at. Their simplicity, using as they did the old-fashioned flowers in simple groupings, made them charming. We cannot do better than to keep in mind the simplicity of style and planting of the old-time gardens, and to plan our own to be as useful and attractive as any room in the house."

Just as Wm. Lyman had wanted to civilize Bruno, rounding out his domestic life by bringing a natural element into it, so Loring saw the garden as a natural and fitting part of ordinary life. Where Wm. Lyman had (tried) to shape his bear's habits and inclinations to fit with his household routine, Loring tended plants, flowers, and shrubs of every description, bringing a tamed and subdued version of nature into the sphere of the New England backyard. Neither brother had a real inclination for the wilderness unmediated by human intervention.

It was out of this love for household gardening that Loring's books, articles, and photographic lectures grew. However much he may have believed in public service as an ideal, his own inclinations were distinctly private – and private in a particularly upper middle-class way. When he wrote and lectured about the garden as a living room or a place of meditation, he naturally and unthinkingly stressed the importance of fences and hedges as ways to keep private life securely outside the view of the public. "They" might find peace or recreation in public parks, but they must not intrude on the privileges of class.

But Loring's sense of privacy did not make him selfish. On the contrary, he was truly committed to making his own enthusiasms and satisfactions more general, and the commitment is evident in his writings. Chief among these were three books: *The Garden and Its Accessories* (1906), *A Garden Diary and Country Home Guide* (1908), and *The Problem of a Small Garden* (1929). All of these books contained photographs which Loring used functionally, as illustrations: he wanted to show his readers what a pergola looked like or how to conceive of garden houses or statuary. By 1905 he confided to his diary, "I spend a good deal of time writing articles." He sent them, generally, to *Country Life in America* or to *Scientific American*. He contributed individual photographs to traveling expositions that the ASLA sponsored, and when he became president of the Boston chapter of ASLA, he set up an exhibit that ran from February 19 to March 1, 1924.

It is more difficult to discover when he began to lecture about gardens and to make the beautiful Autochrome slides which remain his most lasting contribution to photography. We know that he lectured as early as 1903 because he was appointed instructor at the Middlesex School, near Boston, where he reported, his "first lecture went off as well as I expected." In April 1905 he was invited to speak and to show lantern slides at the Photographic Society of Philadelphia, and he also reported that he had had photographs of a garden studio accepted for an art exhibit at the Boston Public Library. But it was not until 1917, in his fifth class report for Harvard, that he identified photography as an important part of his own identity. "In connection with my landscape architecture work, I have recently taken up the photographing of gardens by the new process of 'direct color photography.' I use that to illustrate my lectures on gardens. I throw these pictures, enlarged several times, upon a screen by means of an electronically lighted stereopticon and the reproduction of the true colors is quite remarkable. When the war is over, I hope to make records in this way of many of the gardens of the Old World."

By this time, he had ample reason to name himself as a photographer, for his reputation as a lecturer was probably as wide as Wm. Lyman's, and his audiences equally distinguished: The Technology Club of Boston, the Explorers Club of New York, The Harvard Union, Tufts College, the Boston Society of Natural History, the Brooklyn Institute of Arts and Sciences, the Fogg Art Museum, the Boston Camera Club, the Boston Society of Arts, the Buffalo Society of Natural Science, and the Institute of Arts and Sciences at Columbia University all invited him to lecture and show his photographic work.

Like Wm. Lyman, he settled on a fixed repertoire of lectures: "Old New England Gardens," "The Arnold Arboretum," and "English Homes and Gardens in Surrey" were his accustomed topics. In all of these addresses, he stressed simple, "homelike" qualities. Outdoor space was to be lived in; it was to reflect the personal care of the owners. He abhorred "queer and exotic plants" and gardens built for show or in overly elaborate designs. "The best examples of old New England gardens," he suggested, "show that they have combined the symmetrical design of the formal school with the naturalistic manner of planting [of] the other. There is an air of 'Natural Regularity,' as it were, about these gardens; and in every case they were designed to fit the landscape in which they were placed; and never was there an attempt to change the landscape to fit some preconceived garden design."

As his expertise expanded, so did his reputation. In 1913 he was elected to the board of the Lowthorpe School, an institution dedicated to the education of young women in horticulture and landscape architecture. In 1923, 1924, and 1925 he served as president of the Boston Society of Landscape Architects. He became a visiting examiner of the Harvard Department of Landscape Architecture; in 1925 he was elected to the Board of Trustees at the Massachusetts Horticulture Society. Throughout all these activities, he continued to lecture, with Autochrome after Autochrome, demonstrating the exuberance, the naturalness, the color groupings that he wanted his audiences to recognize as beautiful.

PLATES

Wm. Lyman Underwood

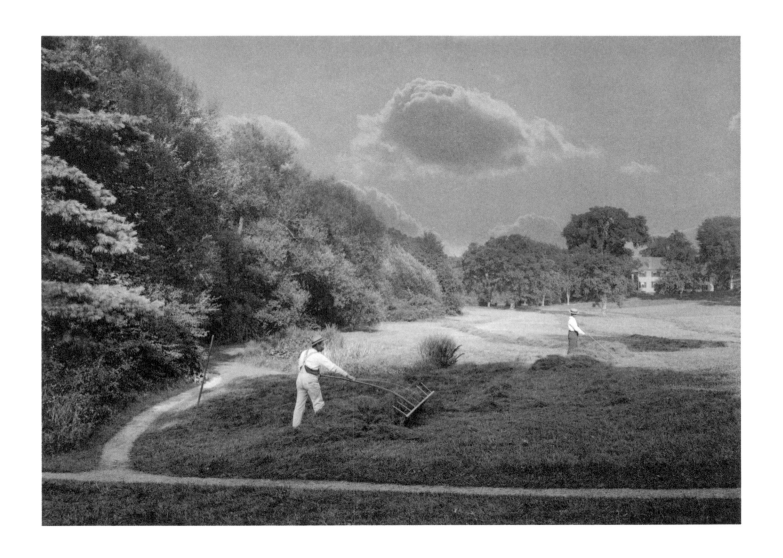

Harrison Smith Haying, Belmont, Massachusetts

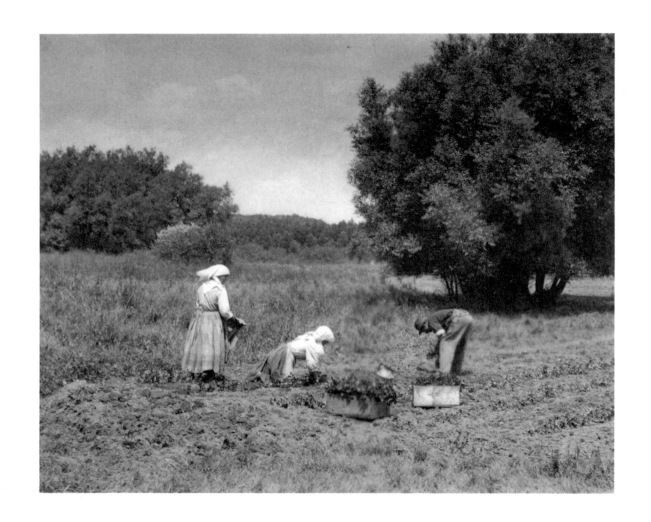

Harvesting, Belmont, Massachusetts

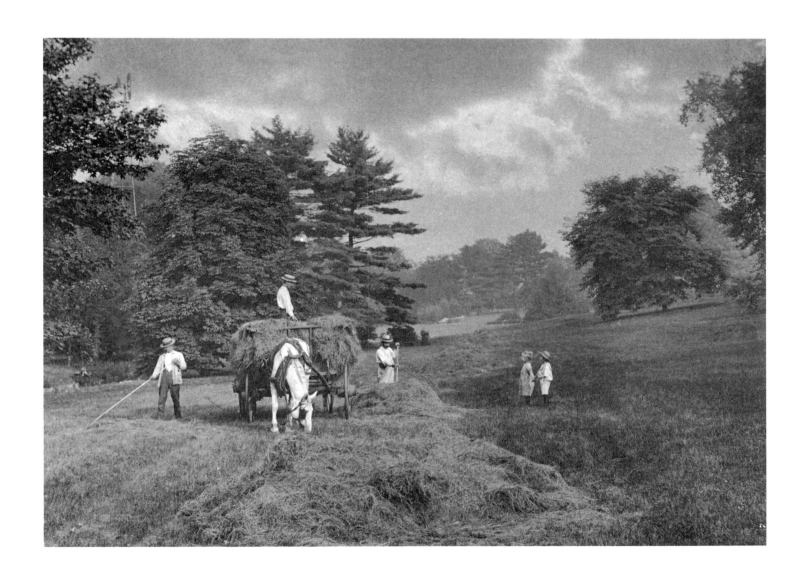

Haying, Belmont, Massachusetts

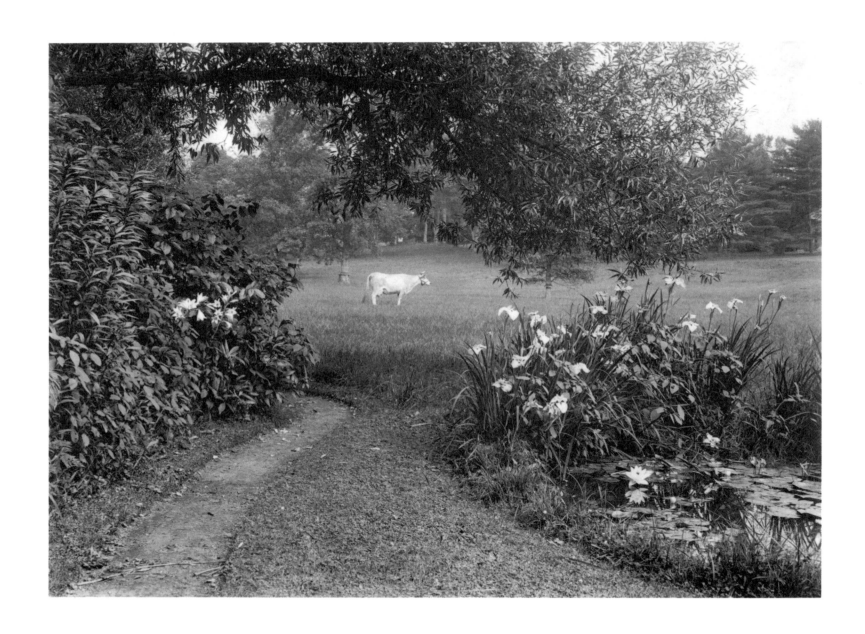

Underwood Estate, Belmont, Massachusetts

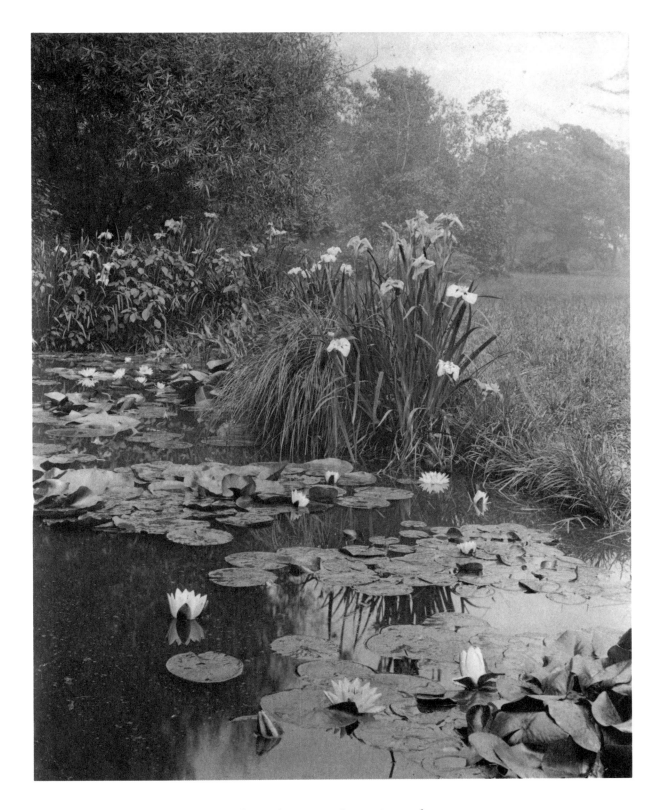

Underwood Estate, Belmont, Massachusetts

Underwood Estate, Belmont, Massachusetts

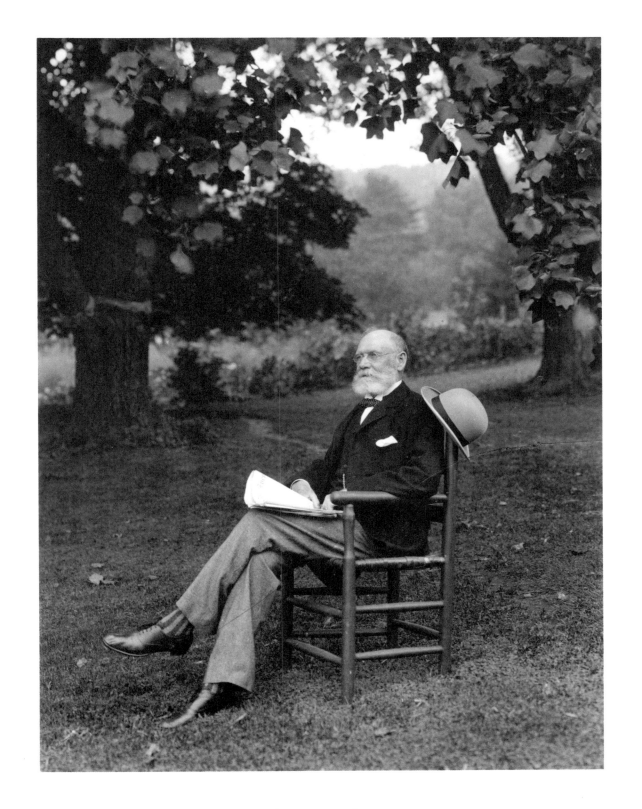

Belmont, Massachusetts

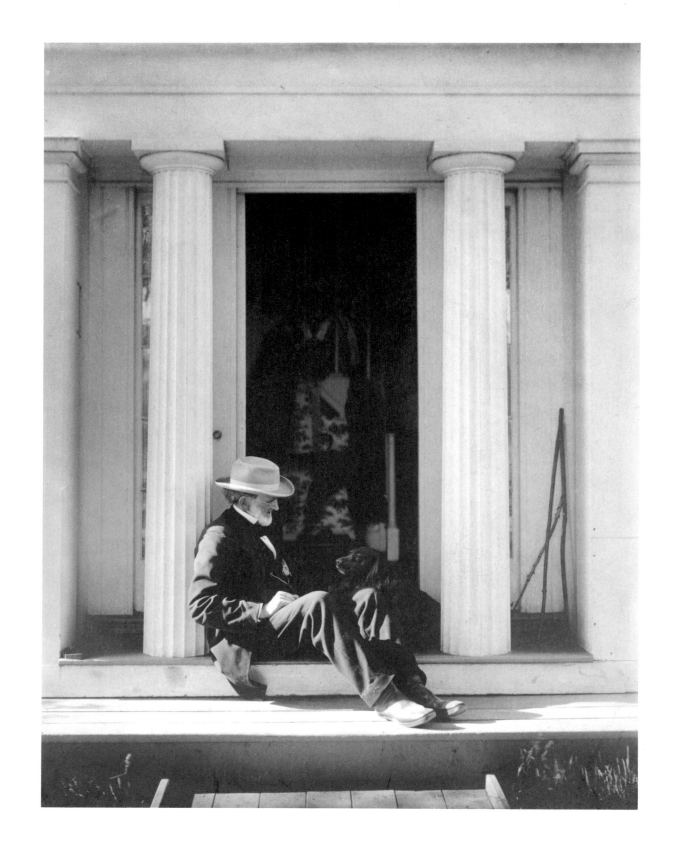

Belmont, Massachusetts

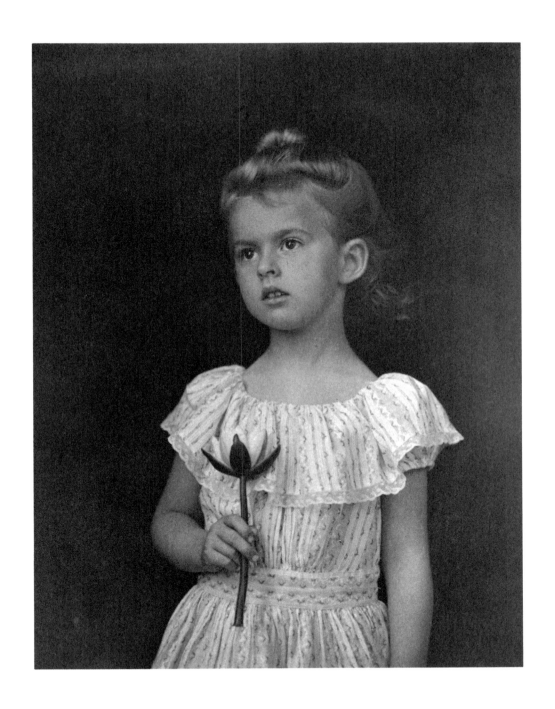

Belmont, Massachusetts

William James Underwood, Belmont, Massachusetts

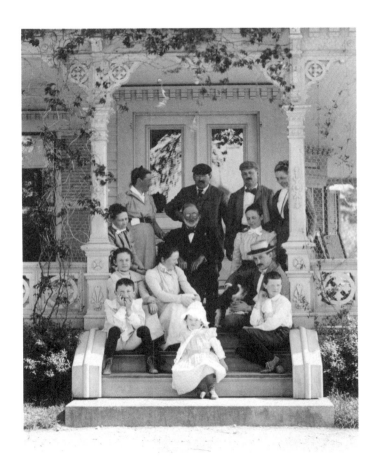

Family Portrait, Belmont, Massachusetts

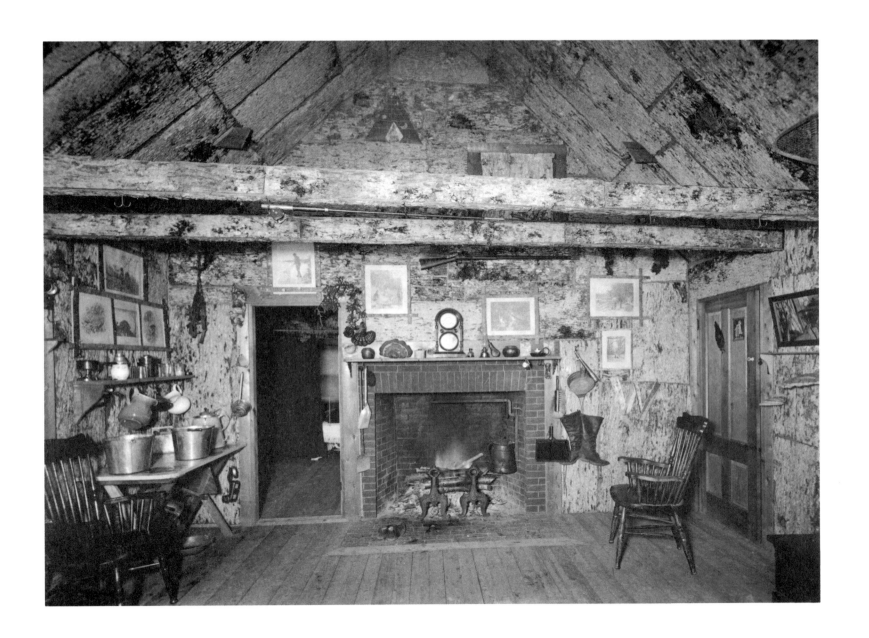

Our Fireplace, Duck Lake, Maine c. 1903

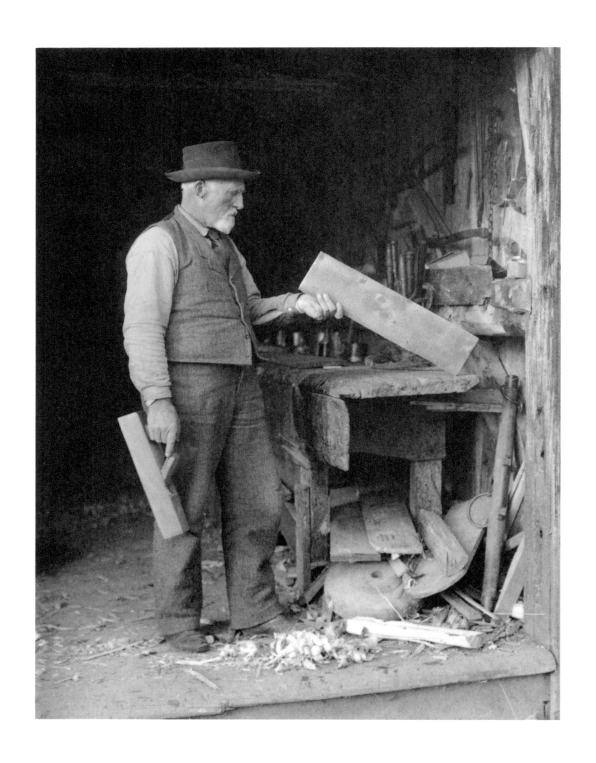

Mr. A. E. Gowell, Duck Lake, Maine

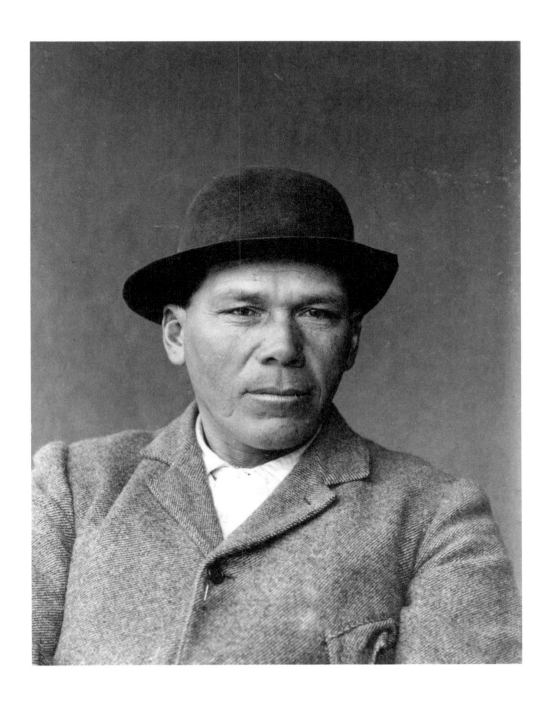

Joe Mell, Indian Guide

Maine

Maine

Schoolhouse, Maine

Town Meeting – Grange Hall, Carroll, Maine 1899

Logger, Maine

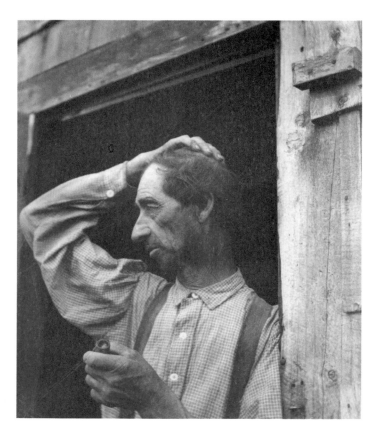

Bill Cucumber, Maine

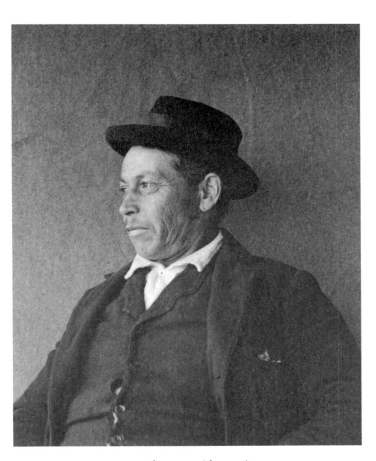

Woodsman Guide, Maine

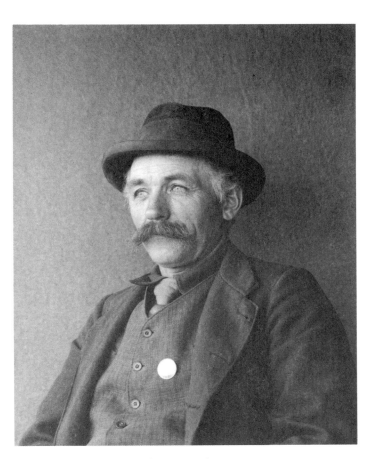

Woodsman Guide, Maine

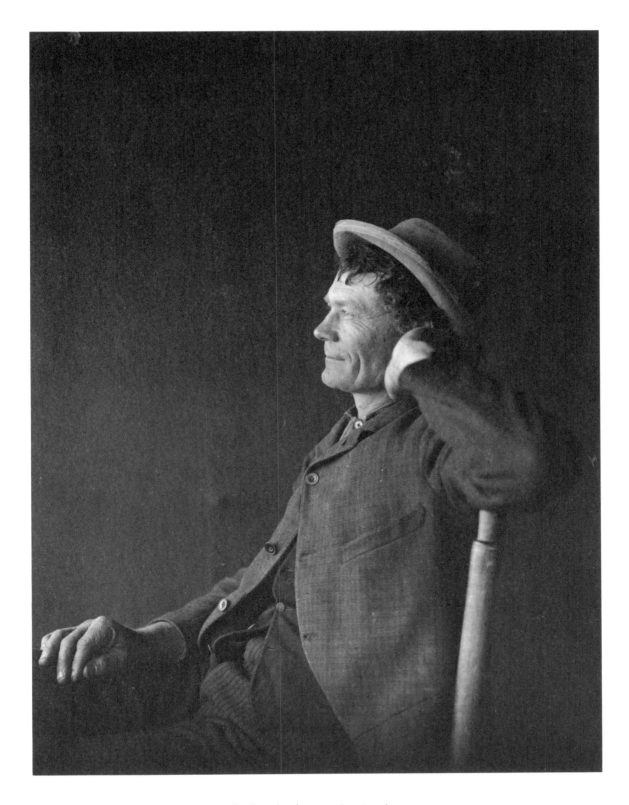

Charles Flanders, Maine Gentleman

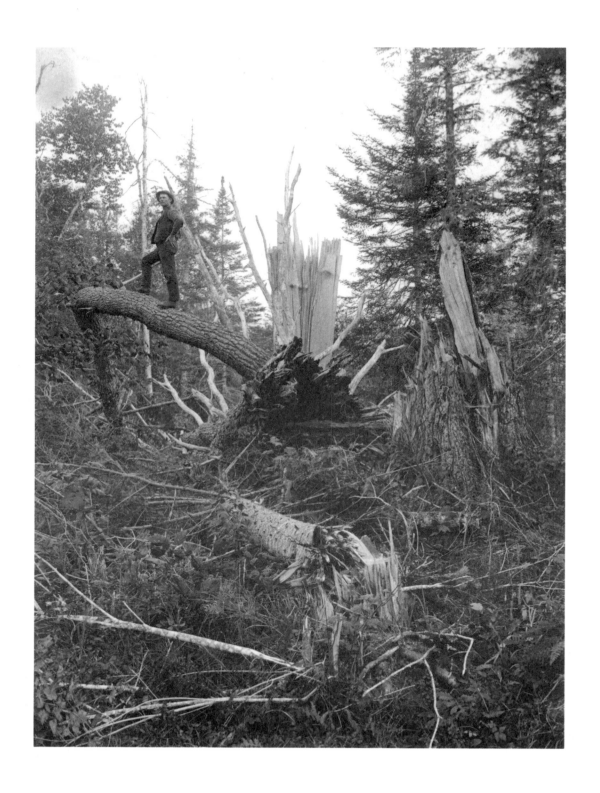

Logger, Maine

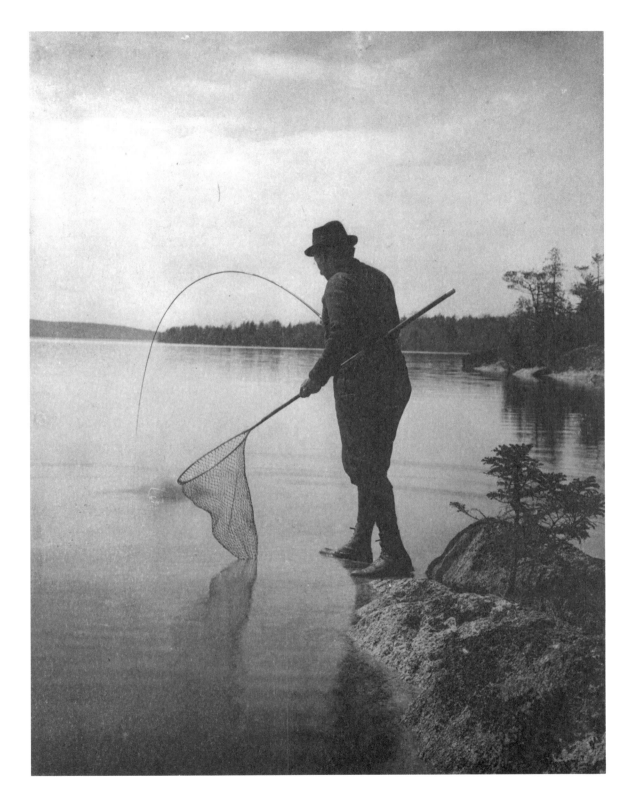

Self-Portrait, Wm. Lyman Underwood, Maine

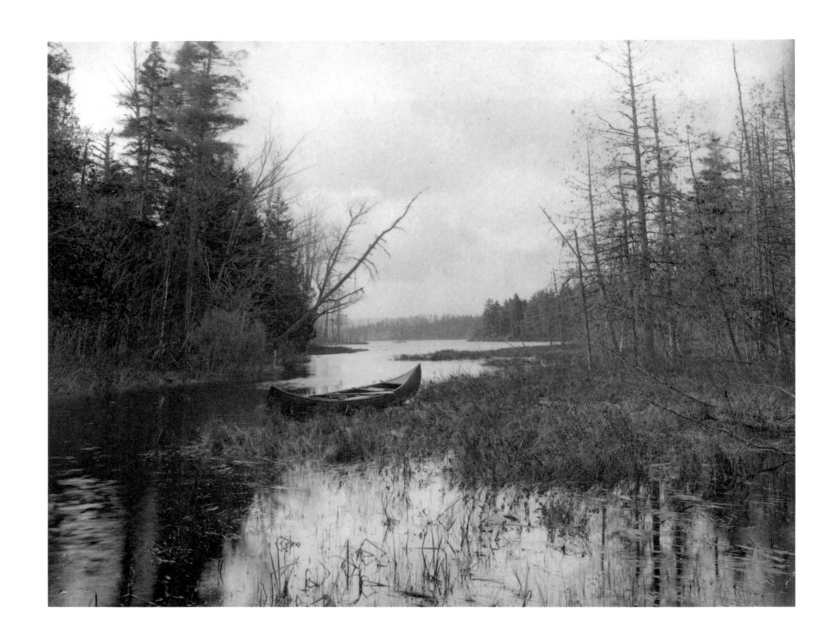

Landscape, Maine

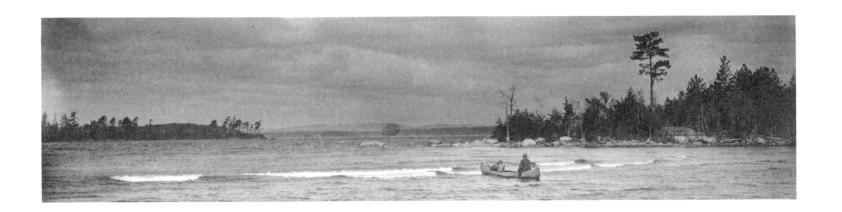

Landscape, Maine

Duck Lake, Maine

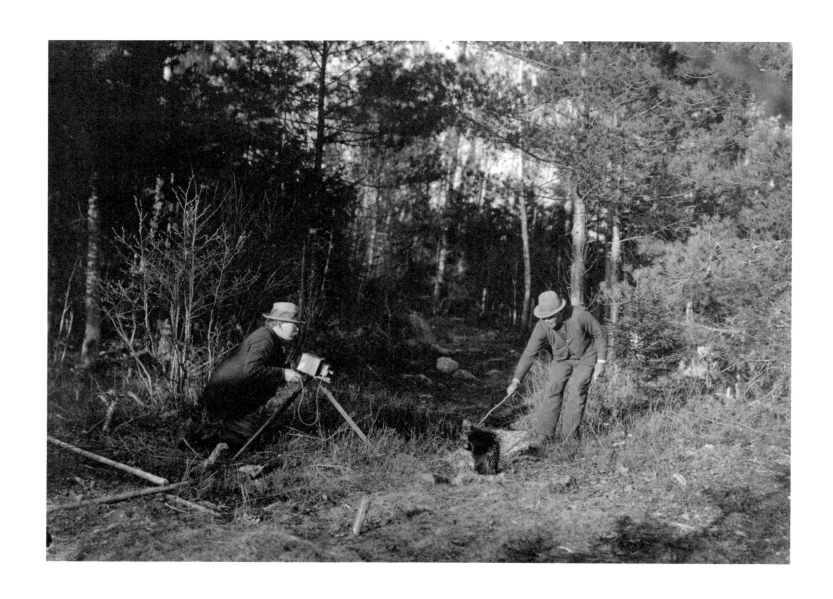

Wm. Lyman Underwood and Joe Mell photographing a porcupine.

AMATEURS, GENTLEMEN PHOTOGRAPHERS
& THE HISTORY OF PHOTOGRAPHY

Joel Snyder

The sharp distinction between amateur and professional photographers is a relatively modern one. Throughout its formative years much of the most important technological and aesthetic innovation in photography was brought about by amateurs, that is, by photographers who did not earn money by taking pictures. It was only after George Eastman introduced the easy-to-use, roll film Kodak camera in 1888 that a large, technically unschooled audience began to make photographic pictures. Prior to the turn of the century, amateurs were every bit as proficient in making photographs as were their professional counterparts. Before the revolution brought about by the Kodak, the only distinction between amateur and professional concerned the way in which a photographer made his living.

As the careers of Loring and Wm. Lyman Underwood illustrate, moreover, the amateur/professional distinction can be quite misleading when it is construed too narrowly. Neither of the brothers undertook photography as a profession, though their work certainly meets professional standards. Nor were they simply part-time dabblers with a strictly avocational interest in the art. Rather, they were gentlemen photographers, or "amateurs" in the original sense of that word: they were "lovers" of the craft who made photographs for the sheer delight of making them and used them to advance the interests of their families, their local communities, and their country.

In producing professional quality work in an amateur manner, gentlemen photographers not only bridged the gap between the vocational and avocational aspects of the art; they also played a significant and often overlooked role in the evolution of photography into its modern form. It is the purpose of this essay to review that evolution, so that the reader may appreciate the contribution of nonprofessionals like the Underwoods in its historical context.

THE FIRST AMATEUR PHOTOGRAPHERS: 1839–1855

Photography was invented simultaneously in France and England in the 1830s and was officially announced to the world in 1839. The two photographic systems were quite different from one another; the French method, named the "daguerreotype" after its inventor, Louis Jacques Mandé Daguerre, produced a one-of-a-kind image on a silver-coated copper plate, while the English system, called "photogenic drawing" by its inventor, W. H. F. Talbot, gave a paper negative from which an indefinite number of positive prints could be made.

The invention of photography was widely greeted with fascination bordering on astonishment, but historians tend to forget that both photographic processes were introduced in a far from perfected state; as a consequence, neither could be put to immediate, practical use. Daguerre's method produced unique, extraordinarily detailed plates, characterized by subtle tones and a beautiful finish, but exposure time was at least half an hour in bright sun, and of course longer on overcast days. Moreover, since the daguerreotype process is not a print medium, it was impossible to make multiple prints from an original plate; this further diminished its practicality. Likewise, the photogenic drawing process was thoroughly impractical both because exposure times in the camera ran over an hour in the bright sun, and

also because prints made from highly detailed paper negatives were far less detailed than the negatives, owing to the presence of paper fibers in the negatives that tended to obliterate fine detail in the print. In 1841, Talbot perfected the calotype process, a new means of making paper negatives, which reduced exposure times to as little as one second, but the problem of making detailed prints with full tonal scales from these negatives remained to be worked out. The new process suffered from another kind of problem as well. Talbot patented the calotype and restricted its free use to noncommercial purposes; anyone who wanted to use it for commerce had to pay him an annual and rather expensive licensing fee.

The news of the invention of the daguerreotype in August, 1839 caused considerable excitement in major cities throughout Europe and the United States and brought about a surprising amount of amateur activity. Wealthy dabblers in the fine arts, some full-time artists, and a handful of dedicated scientists struggled to learn the technology of the new art. Some, like Samuel W. F. B. Morse, the artist and inventor of the telegraph, and Dr. John Draper, a prominent American chemist, were able to produce fine daguerreotypes within weeks of the announcement of the invention. Draper is credited with having made the first successful daguerreotype portrait by fashioning a camera with a remarkable lens system permitting him to photograph in bright sunlight using an exposure of less than three minutes.

After the initial sensation created by the announcement of the daguerreotype began to subside, many of those who had toyed with the new invention turned their attention to other pursuits, while a dedicated group of amateurs in France, England, Germany, and the United States continued to experiment with it. Their discoveries played an important role in the improvement of the process, especially with regard to the reduction of exposure time. By early 1844, the improvements made by these amateurs reduced exposure time from Daguerre's thirty minutes in bright sun to ten seconds in a well-lit studio, allowing for the relatively easy production of studio daguerreotype portraits. Ironically, this advancement of the state of the art by amateurs created the conditions for the first large-scale commercial use of photography – the production of portraits for a large and growing audience. During the late 1840s the ranks of professional photographers grew rapidly, and businesses serving the photographic trade, like the firm of E. and H. T. Anthony (the forerunner of the Ansco Company and the GAF Corporation) grew along with it. These photographic stock houses provided equipment and materials for both amateurs and professionals and by the early 1860s took over some of the photographic experimentation previously done by amateurs. A few amateur daguerreotypists, however, continued their experiments in an effort to discover a chemical process for producing full-color daguerreotypes. An amateur enthusiast, the Reverend Levi P. Hill of Westkill, New York, created a sensation when he announced the invention of such a process in the late 1840s. Hill's method produced daguerreotypes in "full natural colors," and affidavits signed by such unimpeachable sources as Samuel W. F. B. Morse attested to the truth of Hill's claims. Unfortunately, Hill was unable to produce acceptable results with any consistency, and others found his method impractical. Hill's experiments provide, nonetheless, a fascinating puzzle for modern investigators and point to the complexity and sophistication of early amateur experimentation with the daguerreotype.

Inexplicably, the professionalizing of work on the daguerreotype coincided with the end of amateur activity. By the early 1850s, only a handful of amateur daguerreotypists continued to experiment with the process.

During the 1840s and through the mid-1850s, "photograph" and "daguerreotype" were practically synonymous terms, and the chief virtue of the daguerreotype process – its ability to record fine detail with great precision – came to be thought of as the hallmark of all photographic processes. As far as the broad, popular audience was concerned, the daguerreotype set the standard for photographic depiction. Yet Daguerre's process, improved as it was by numerous amateur photographers, proved to be a dead end for the new medium. It was Talbot's negative/positive process that provided the foundations of modern photographic technology.

Talbot's patent restricted the commercial application of the calotype, but the truth of the matter is that very few entrepreneurs viewed it as having any potential for economic exploita-

tion, and those who did came to know better. Prints made from early calotype negatives have none of the features that gave the daguerreotype its great popularity; their tonal scales tended to be abrupt and high in contrast, and the fine detail found in the negative was almost impossible to maintain in the print. Compared to daguerreotypes, early calotype prints were merely suggestive. However, while these prints failed to meet the popular standards of photographic depiction established by daguerreotypes, they were in many formal respects rather like the prints and paintings of contemporary artists. European painters – Turner, Constable, Delacroix, and Courbet, among many others – were committed to an art of suggestion, one in which details were de-emphasized in favor of broad, suggestive masses. Viewed from the perspective of artists and lovers of art, the daguerreotype was inherently inartistic, because its apparently limitless appetite for detail and the highly finished character of its surface were in absolute opposition to the prevailing standards of art; calotype prints, on the other hand, reflected the dominant values of visual art.

By the mid-1840s, the calotype had been adopted by a small number of primarily well-educated and generally well-born men in Great Britain and France who were devoted to its improvement and to its use as a medium of pictorial expression. While a fair number of these gentlemen amateurs had studied painting and knew the history of art, it would be misleading to think of them as being devoted to the creation of a photographic art; rather, they were serious picture-makers whose photographs reflect the aesthetic sensibilities of their time.

Sir David Brewster, the great Scottish scientist, was among the first champions of the calotype in Scotland and introduced it to a number of his countrymen, including Robert Adamson, a physician. Adamson studied the technique, becoming quite adept at its use, and taught it in turn to the noted painter, David Octavius Hill. Together, Hill and Adamson produced some of the finest scenic and portrait photographs made in the last century. Both had essentially an amateur's interest in photography, although a large number of Hill's calotype portraits were made as studies for his paintings.

A few of Talbot's countrymen, devoted to the paper negative process, formed clubs and associations permitting them to share technical improvements and to follow the pictorial activities of their fellow photographers. The Calotype Club sponsored albums that were sent by post from member to member, each adding his latest and best pictures to the album before sending it on. The club consisted of men like Sir Henry Pollock, who was to become the chief justice of the British courts; Roger Fenton, an artist turned lawyer who was later to photograph the Crimean War; and Dr. Hugh Diamond, a physician who devoted his life to the study and treatment of the insane. These British amateurs established one of the first journals devoted to the study and discussion of photography and the first annual, juried exhibitions of amateur work. A number of these devoted British amateurs prevailed on Queen Victoria to establish the Photographic Society of Great Britain in 1853 which later became the Royal Photographic Society.

The calotype was also adopted by a number of French amateurs, who came primarily from the ranks of artists, businessmen, and civil servants. Again, these amateurs were drawn to the process by the characteristic naturalism of its prints. Amateurs, some of whom later became professionals, like Edouard Leydreau, Edouard-Denis Baldus, Maxime Du Camp, and Gustave Le Gray, produced a remarkable body of work that remains one of the monuments of photographic production. Like their British counterparts, these amateurs founded photographic journals and societies and encouraged both professional and amateur scientific investigations into photographic chemistry and optics.

The British and French amateurs made significant technical improvements to Talbot's process. By the late 1840s, the popular demand for greater clarity in photographs, created by the broad acceptance of the daguerreotype, began to make itself felt, even among the amateur calotypists. Joseph Cundell in England and Gustave Le Gray in France experimented with significant variations of the process, greatly increasing the ability of paper negatives to render fine detail and to give prints with remarkably rich tonal values. The desire for increased clarity in calotype prints led inevitably to the search for a means of coating photosensitive chemicals on glass instead of paper. By 1850 a number

of elegant techniques for doing this were proposed by French and British calotypists, but despite their successful application to scenic and architectural photography, these methods proved to be too time-consuming and demanding for most amateurs.

In 1851 Frederick Scott Archer, an English amateur photographer, published an essay in a prominent scientific journal, *The Chemist*, announcing a revolutionary method for preparing negatives on glass. The method used collodion, a recently invented substance made by mixing ether, alcohol, and linen that had been boiled in a mixture of sulfuric and nitric acid. Collodion is a viscous liquid that dries rapidly into a thin, tough, and perfectly transparent film that is very much like cellophane. Scott Archer's method of making negatives utilized the chemistry of the calotype process – in effect it was Talbot's process transferred to glass – and so its commercial use was in direct violation of his patent. The new method, called the wet plate process because the collodion-coated glass had to be exposed, returned to the darkroom, and developed before it dried, was not substantially simpler than the paper negative process, but it was more predictable; more importantly, it produced prints rivaling the daguerreotype in clarity and fullness of tonal range. Moreover, unlike the daguerreotype, it allowed for the unbounded duplication of prints. By the mid-1850s this process, invented and perfected by an amateur, had almost completely replaced both the daguerreotype and the calotype and transformed photography once and for all into a print medium. In the mid-1850s Talbot attempted to enforce his patent by arguing that wet collodion photography depended upon the chemicals and manipulations covered by his patent, and while the court ruled in his favor, it also found that the practice of wet plate photography had become so widespread as to make the patent unenforceable.

Wet Plate Photography & the Amateur: 1855–1880

Professional daguerreotypists found the transition to wet plate photography to be a relatively easy one, but they had to adjust their former working methods to the new and considerable demand for photographic prints. With a few notable exceptions, daguerreotype studios were run by a proprietor photographer together with one or two assistants. The wet plate system of photography, however, required a division of labor between the camera operator, a person or staff in charge of making and developing the wet plates in the darkroom, and a staff that printed the negatives. Making photographic prints from glass negatives was a tedious, time-consuming, and labor-intensive job. In order to make usable photographic paper, one worker had to float large sheets of previously prepared paper upon a solution of silver nitrate and hang it to dry in the dark; another person had to cut the sensitized paper into appropriate sizes; yet another placed a negative on top of a piece of sensitized paper, pressed the two together inside a printing frame, and walked it to a rooftop, where it stayed under bright sunlight until it received sufficient exposure. Depending on the size of the photographer's studio, anywhere from a few to hundreds of frames might be printed in the sun at one time. Since the output of sunlight varies, the printing time for negatives did too, and printers had to race furiously back and forth from frame to frame, checking on each print's progress. Print exposures could run anywhere from five minutes to two hours in the bright sun. When the prints had been fully exposed, another worker had to bring the frames to the processing area, remove the prints, and hand them to a processor, who would then wash the still light-sensitive prints in water, tone them in a solution containing gold chloride, and then make them permanent by fixing them. After this processing, they were washed in running water for an hour and then glued, still wet, to cardboard mounts. In many cases the mounted prints were cranked through the heated rollers of a burnishing machine to give them a high gloss. It was not unusual for busy small-town photographers to require seven or eight assistants at all times, while some highly successful photographers in large cities employed as many as sixty workers on a daily twelve-hour shift.

One result of this splitting of functions in professional photography was the fragmentation of the skills required to produce photographs. The division of labor characterizing modern industrial manufacture was firmly established in professional photography by the mid-1860s, and this meant that the studio

owner was sometimes a photographer in name only (this was true, for example, of the famous Civil War photographer, Mathew Brady). Under these circumstances, the previously loose distinction between professional and amateur photographers evolved, rather abruptly, into a very well-defined one. Professionals formed trade associations and came gradually to see most of the issues of photographic technology and aesthetics in terms of economic questions. Amateurs, on the other hand, remained devoted to the practice of photographic picture-making for motives that were not economic but artistic and technical: they had to master each and every operation required for the production of negatives and prints. Amateurs became the generalists of photography, while the professionals tended, with a few noteworthy exceptions, to be the specialists.

Because the collodion process required on-the-spot manufacture and processing of photographic plates, photographers were tied to their darkrooms (plates were poured, sensitized, developed, and processed in the same darkroom). In order to make scenic or architectural views, it was necessary to go into the field equipped with a portable darkroom. The considerable investment in such portable apparatus and the difficulty of carrying it about prevented most amateurs from engaging in scenic photography with the wet plate process. This fact accounts for the considerable amount of amateur activity devoted to the preparation of moist or nearly dry collodion plates that could be made in a home darkroom, exposed in the field within a few days, and returned to the darkroom for processing. Amateurs in England and the United States made considerable technical advances in the production of these kinds of plates and produced remarkable landscape photographs with them.

Julia Margaret Cameron was perhaps the greatest of all amateur photographers of the wet plate period. In many ways she is typical of the upper-class amateurs who worked in the wet plate period, though in some ways she towers over all the photographers of her time. Cameron was in her forties when she was introduced to photography. Unlike nearly all the photographers of her time, she was not terribly concerned with the technical details of the craft, but she came to see its expressive capacities in an entirely new way; as a consequence, her photographs are quite unlike those of amateurs and professionals of her time. By 1866, when Cameron began making photographs, studio portraiture had become highly formulaic. The sitter sat with his or her neck held immobile by a concealed neck brace; the background was a neutral gray or a painted view of nature; the light was generally soft and only slightly directional. Thus, studio portraits were little more than likenesses – razor-sharp pictures of their subjects showing little if anything of the sitter's personality.

Unfettered by the need to please paying customers, Cameron broke all the rules of professional portraiture to produce portraits that go far beyond likeness. Her portraits of England's greatest poets, writers, and thinkers – including Tennyson and Carlyle – are pure evocations of personality, suggesting the power of her penetrating vision.

THE DRY PLATE AMATEURS: 1880–1910

Photographing with wet plates was difficult, demanding, and (because of the use of toxic and explosive chemicals) dangerous for both amateurs and professionals, and the photographic journals of the 1860s and 1870s are filled with articles calling for a simpler and more predictable process. In 1871 a British physician and amateur photographer, Richard Leach Maddox, published an essay announcing a method of making dry photographic plates by suspending light-sensitive chemicals in gelatin, coating the emulsion on glass plates, and allowing them to dry in the dark. This essay provided the basis for experiments improving on Maddox's process, and in 1878 reliable gelatin dry plates were first manufactured commercially in Great Britain. They were soon manufactured and marketed throughout the world.

Dry plates did more than get photographers out of the business of preparing their own photographic plates. The new plates were many times more sensitive than wet plates, and by allowing for instantaneous exposures they put the means for "freezing motion" within the reach of all photographers. Until the commercial production of dry plates, shutters for cameras were unnecessary items, since exposures were counted in seconds.

Exposures of a tenth of a second or less were common with first-generation dry plates, and accordingly shutters became a necessary addition for all cameras. Professionals were rather conservative in their approach to dry plates, but amateurs were quick to adopt the new materials and the new cameras. As a result, a number of entrepreneurs saw the possibility of a growing amateur interest in photography and began to design cameras and materials especially for the amateurs or for a combined professional and amateur market.

The chemistry that made dry plates possible also provided the basis for a revolutionary, highly light-sensitive kind of photographic printing paper. These new gelatin bromide and gelatin chlorobromide papers did not require long exposures to sunlight for the production of photographic prints – all they needed were a few seconds' exposure to artificial light. It now became possible to make enlargements from negatives by means of a photographic enlarger equipped with an electric light bulb. The ease of making enlargements from small negatives allowed camera manufacturers to design and sell smaller, more portable cameras which were aimed specifically at the amateur market. Most of these cameras were disdained by professionals, who dismissed them as mere toys, but amateurs soon became devoted to them and to the spontaneity they permitted. The spontaneous, informal, of-the-moment pictures they produced came to be called "snap shots" – to this day the special province of amateurs.

During the first few years of the dry plate era, amateur photography was slowly transformed from a pastime for those with sufficient free time and money to devote to the demanding photographic process into a relatively popular hobby for the rapidly growing middle class as well. The standardizing of plates, printing papers, and processing chemistry brought predictability and comparative ease to darkroom work and allowed amateurs increasing freedom to experiment with the expressive as well as the technical aspects of their craft.

The photographic production of the Underwood brothers exemplifies the work and many of the interests of advanced, nonprofessional photographers of the dry plate period. For the most part, the brothers used large, bulky cameras requiring substantial tripods for their support. Although the manufacturers of photographic products strived for increasing simplicity of use for both plates and cameras, photographers like the Underwoods took special delight in using the newest, most complicated materials and equipment in their efforts to produce new kinds of photographs, or to depict rarely photographed phenomena. They experimented with nocturnal photography, for example, and like Eadweard Muybridge and, much later, Harold Edgerton, were fascinated with catching motion on film. For inventive and pragmatic Yankee businessmen like the Underwoods, the urge to use the newest materials and to devise personal, idiosyncratic solutions to complex photographic problems must have been irresistible.

Loring Underwood's adoption of Autochrome brand plates to photograph noteworthy gardens, many of his own construction, is a case in point. Black and white photographs can only hint at the pleasures of a picturesque garden, and Loring Underwood saw the advantage of using the new, full-color Autochrome plates (introduced commercially in 1906) for the promotion of his work as a landscape architect and to illustrate his occasional lectures. Full-color photography required considerable patience, ingenuity and fortitude. Prior to going into the field, he would load a number of 5 by 7 inch holders with fresh Autochrome plates in his darkroom or a closet. Once in the field, he would set up his camera on its tripod, compose a view on the camera's ground-glass screen, and then insert a loaded plate holder in his camera. Exposure was determined with the aid of the instructions packed with the Autochrome plates, but was largely a hit-or-miss affair. Because of this, it was usually necessary to make four or five exposures of each view, in the hope that at least one of the exposures was the correct one for the scene. Since each loaded plate holder weighed nearly two pounds and took up considerable room in the camera case, very few photographers went into the field with more than ten loaded plate holders at one time. Additionally, Autochrome plates were considerably less sensitive to light than were ordinary black and white plates (on average, about six times slower) and generally required a full second of exposure in bright light. On days in which a stiff wind was blowing, foliage, flowers, and grass would register as swirls of color on the finished plates.

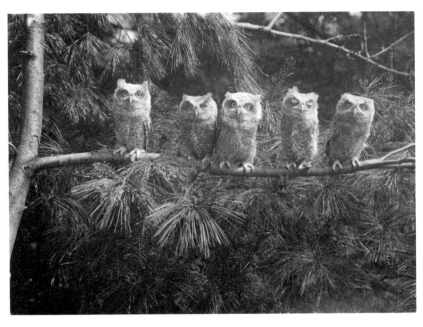

Owls

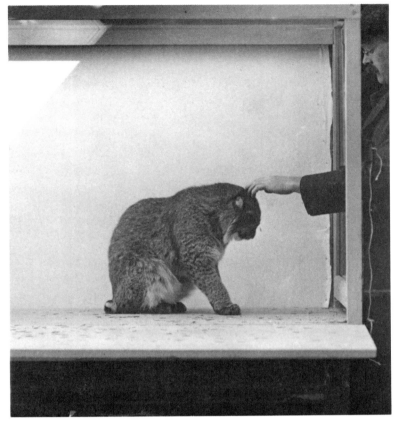

Wm. Lyman and lynx

Once the plates were exposed, they had to be carefully and individually processed in total darkness. This was a somewhat tricky affair, since the chemistry differed substantially from that used for normal black and white work. Each plate was developed in a tray for about fifteen minutes, and the tray had to be rocked from side to side throughout development. The resulting negative had to be transformed into a positive by exposing it briefly to a bright electric light, bleaching it in a toxic chemical bath (this is called reversal processing), and redeveloping the image. The resulting color transparency was then washed in running water, dried, and protected by a cover glass.

In formal terms, Loring Underwood's views of European and American gardens are picturesque. They provide the viewer with an easy point of entry into the depicted scene and often emphasize asymmetrical, meandering pathways through it. In his most successful plates, the multicolored dot structure of the Autochrome material gives the transparencies an impressionist, Seurat-like ambience.

While Loring and Wm. Lyman Underwood's landscape views show their commitment to the picturesque conventions of their time, Wm. Lyman's photographs are not limited to gardens and scenic views. His photographs span a considerable range of subjects: operations at family-owned canning facilities; family life; outdoor life in the Maine wilderness; rural families and their home life; genre pictures of mischievous children, kittens, and puppies; domesticated wild animals (including Bruno, his pet bear); wild animals and birds in their natural habitat; and rural life in the southern United States.

Wm. Lyman Underwood was not a pioneer in the expressive aspects of picture-making; with rare exceptions he composed his pictures according to the then prevailing and comfortable conventions of photographic illustration. But he was an adept and gifted picture-maker within the confines of these conventions, and his published work in periodicals like *Photo Era* and *The Open Road* handsomely demonstrates this fact. Underwood earned his reputation as a pioneering photographer-naturalist by combining his ability to make formally precise photographs with a genius for technical improvisation. He fitted large-format cameras with heavy telephoto lenses and adapted them for use in canoes and on packing trips into the wilderness. He improvised a system of flashlight photography permitting him to photograph animals at night in the wild. For all the technical improvisation and difficulties of working under nearly impossible conditions, most of Underwood's photographs are robustly composed and elegantly printed. Many look like photographs originating in a studio and were doubtless made with this intent.

From Dry Plates to Film

Photographers have always wanted evermore portable cameras in order to photograph when and where they choose. Wm. Lyman Underwood's heroic efforts with large-format, dry plate cameras were necessitated by the technology of his time. The invention of transparent, tough, and flexible plastic films in the 1870s provided the foundation for a genuine revolution in photography. George Eastman was one of the first photographic entrepreneurs to see the advantages of roll film – film that would permit a photographer to make a number of exposures on a surface weighing less than a single dry plate in its holder, and that could be processed in the same amount of time it took to develop that single plate. Nonprofessional photography was transformed from a pastime for the relatively few to a hobby within reach of nearly all by Eastman's technical and marketing genius. Although it might not have seemed to be a revolutionary instrument at the time, the seeds of this transformation of photography were sown with the introduction of the first Kodak camera in 1888. The Kodak was loaded with a roll of film on which 100 exposures were to be made. Once the entire roll was exposed, the camera itself was returned to Eastman in Rochester, New York, where the film was removed and processed. The resulting negatives were then printed and the reloaded camera, together with the negatives and prints, were returned to the photographer. The Kodak camera cost twenty-five dollars, and the price of processing the photographs and reloading the camera was an additional five dollars. The original Kodak was thus an expensive picture-making machine for those wealthy people who had no desire to learn the fundamentals of the photographic craft.

Eastman saw, however, that his company could mass produce inexpensive cameras, film, chemicals, and photographic paper for a market that had not yet come into existence – that is, for the vast number of Americans who might want to make photographs but who could not afford the outlay of time or money required by the dry plate system. Within ten years of the introduction of the Kodak camera, roll film photography had established itself in the United States and western Europe. Once again, it was the nonprofessional photographers who championed the cause of the new system and the professionals who had to be educated by them. The impact of the ubiquitous and inexpensive roll film camera forms an exciting and as yet an uncompleted chapter of photographic history. It also forms an important chapter in the history of the democratization of the arts in America.

PLATES

Loring Underwood

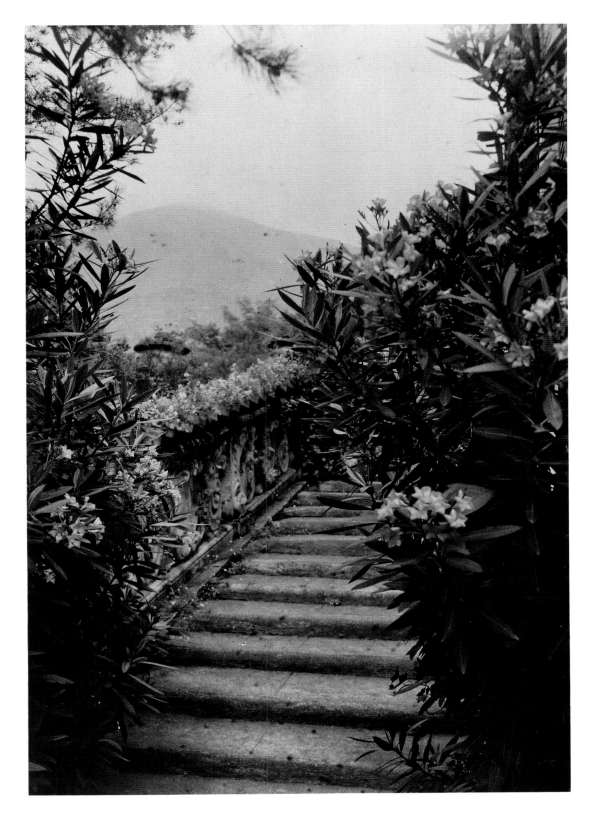

Italy

Location unknown

Mount Vernon, Virginia

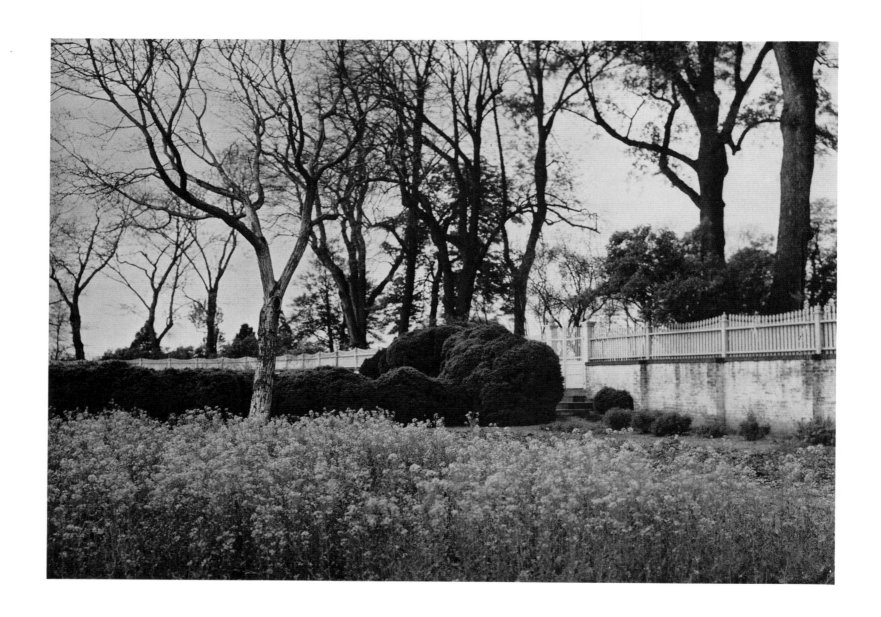

Mount Vernon, Virginia

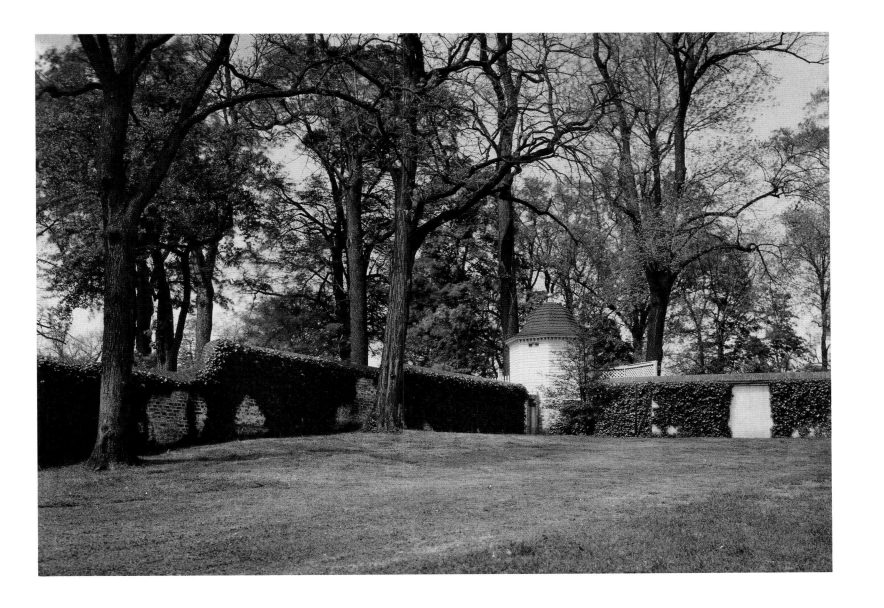

Mount Vernon, Virginia

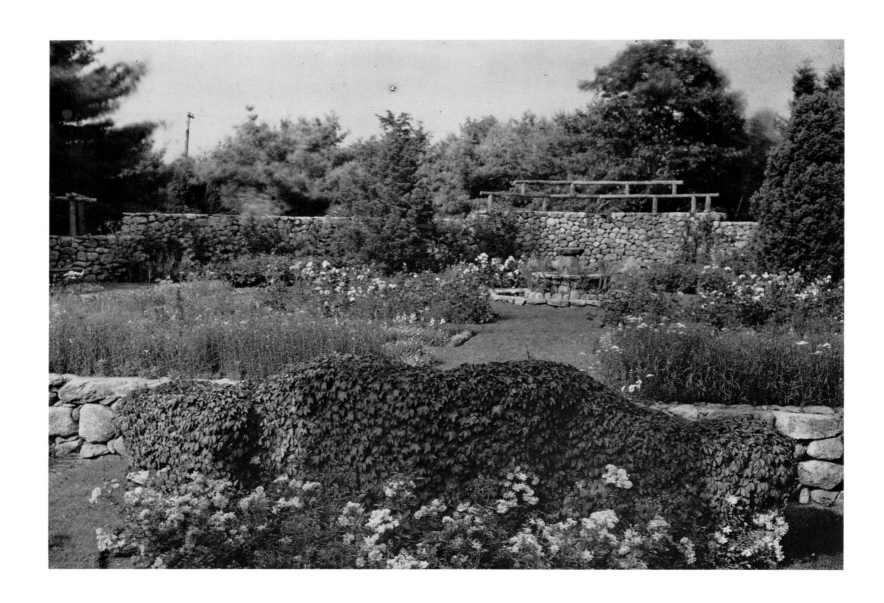

Location unknown

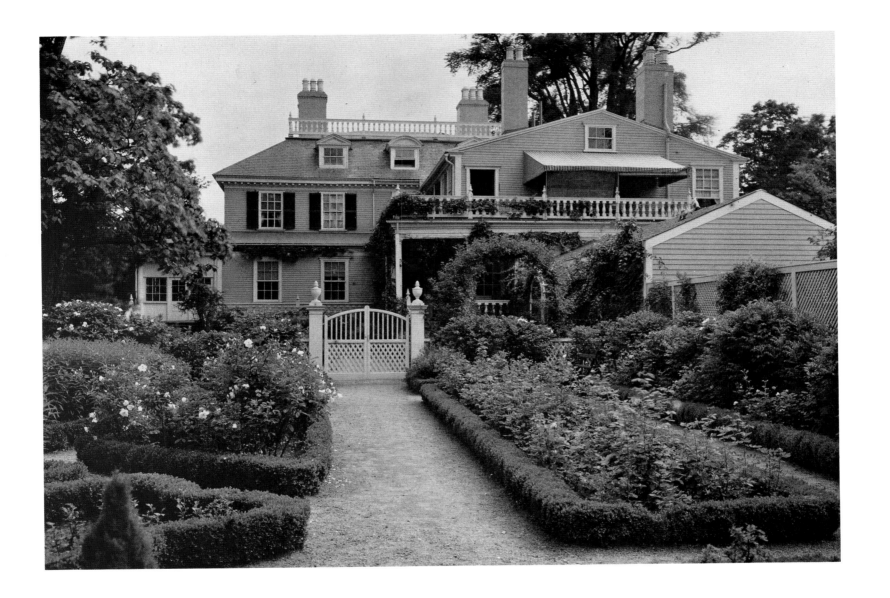

Belmont, Massachusetts

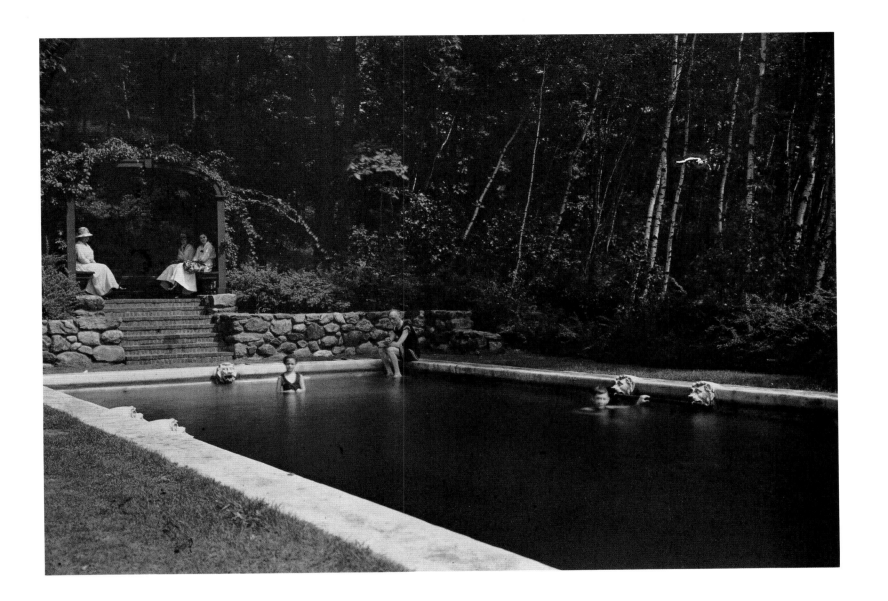

Location unknown

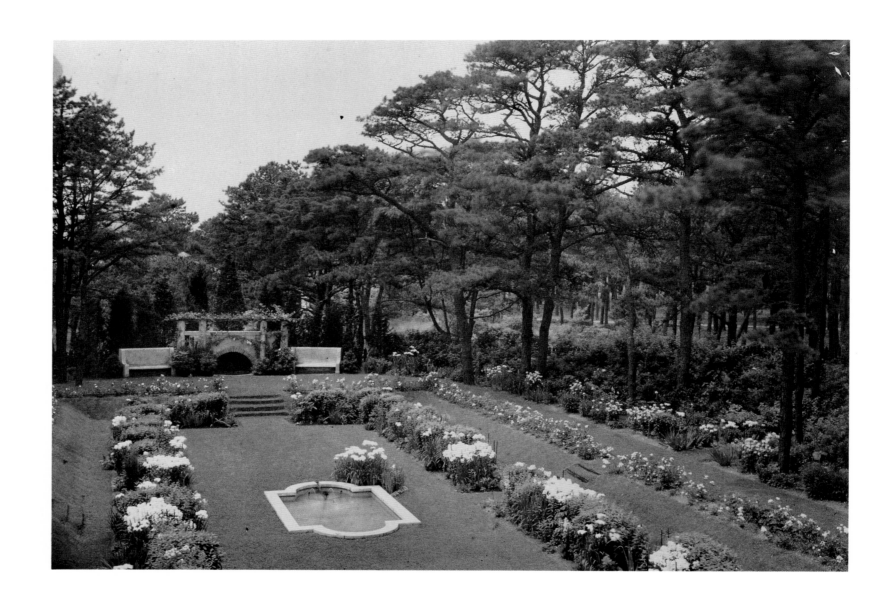

Moon Garden, Wianno, Massachusetts

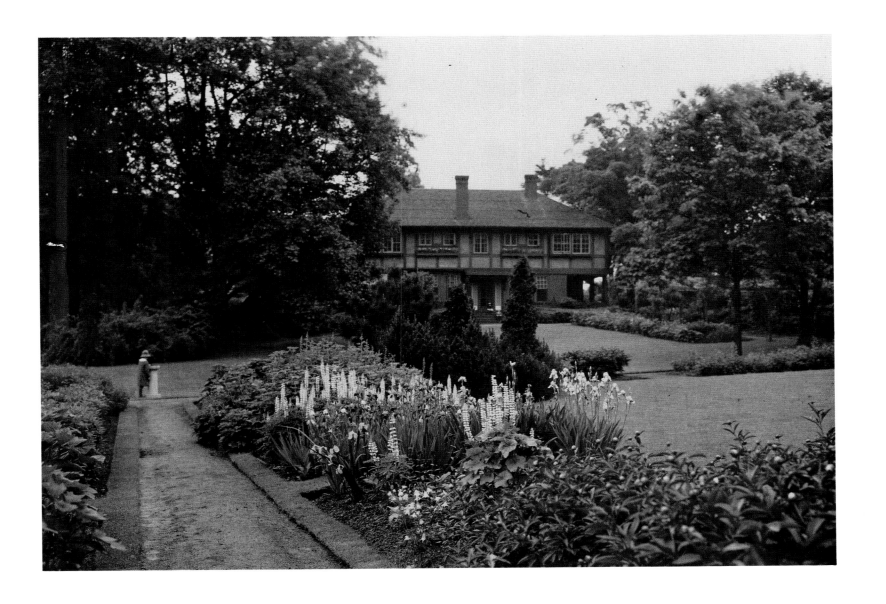

Underwood Estate, Belmont, Massachusetts

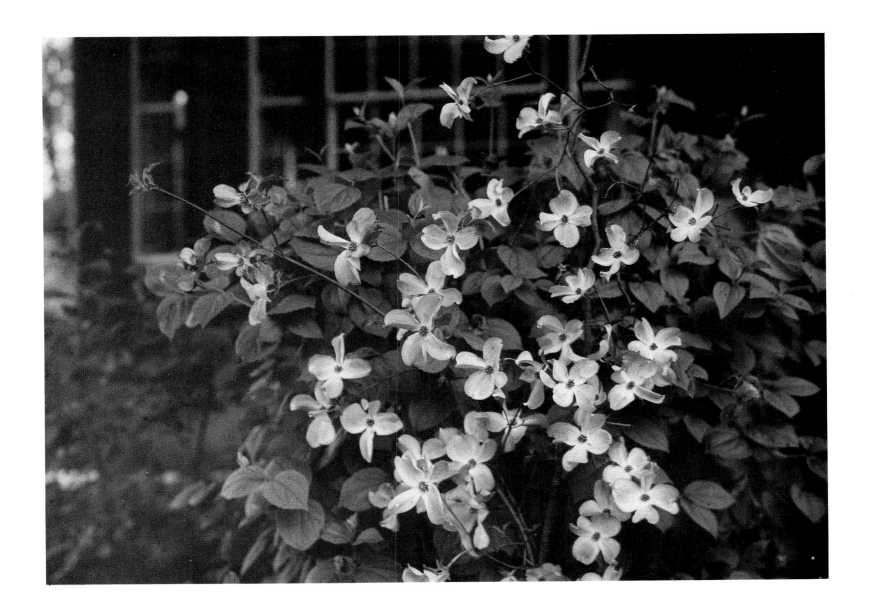

Dogwood, Cape Cod, Massachusetts

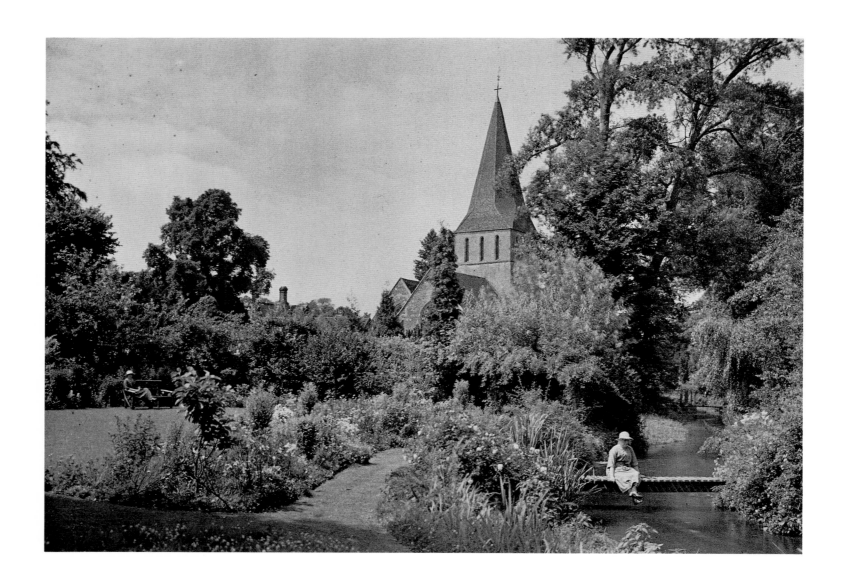

England

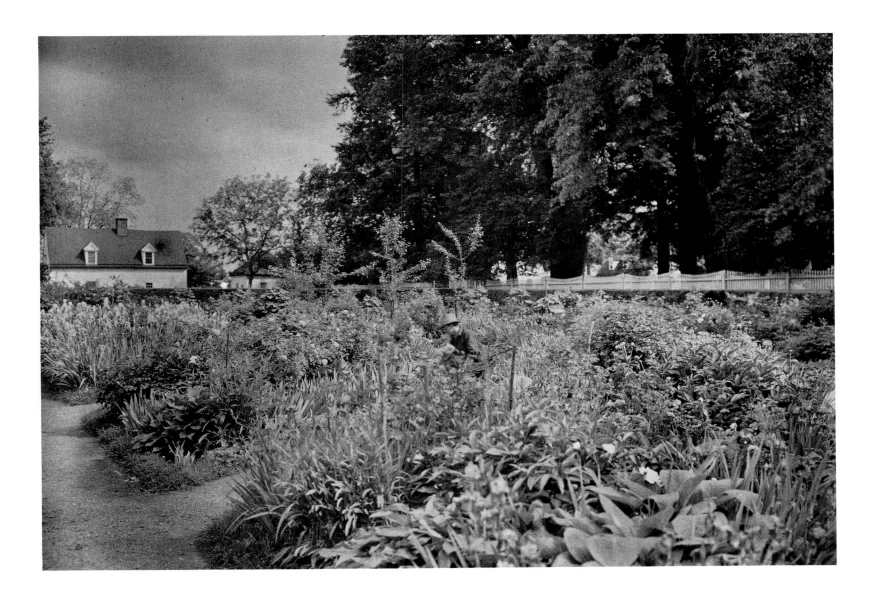

Location unknown

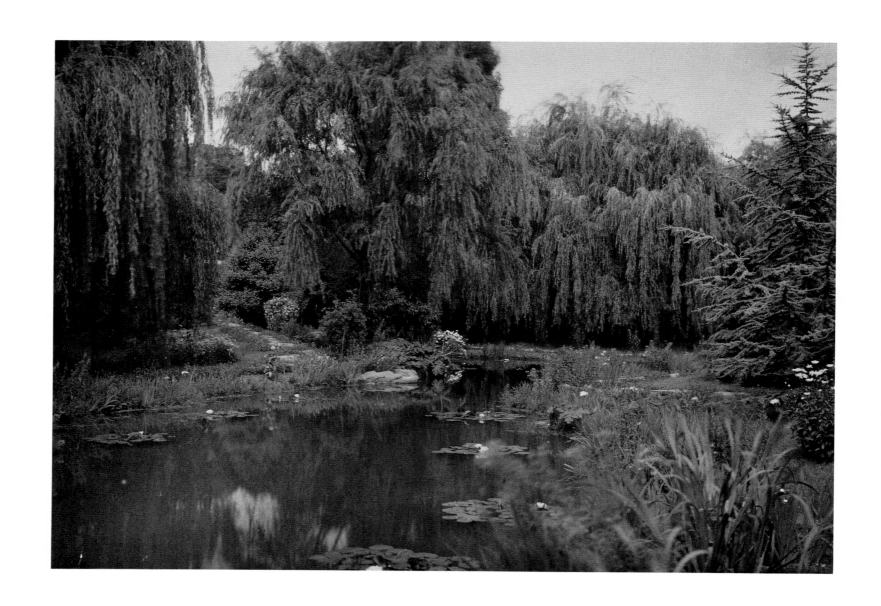

Location unknown

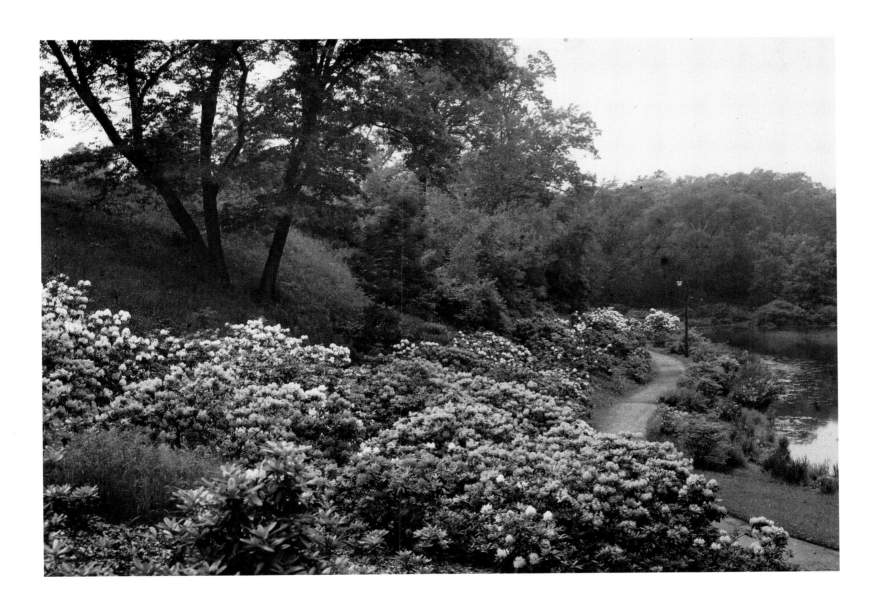

The Jamaicaway, Boston, Massachusetts

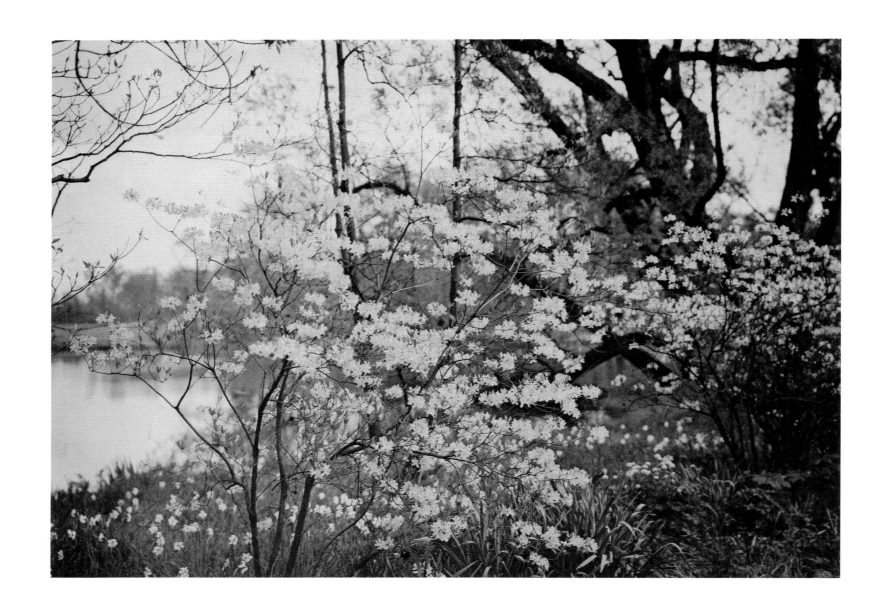

Arnold Arboretum, Boston, Massachusetts

Location unknown

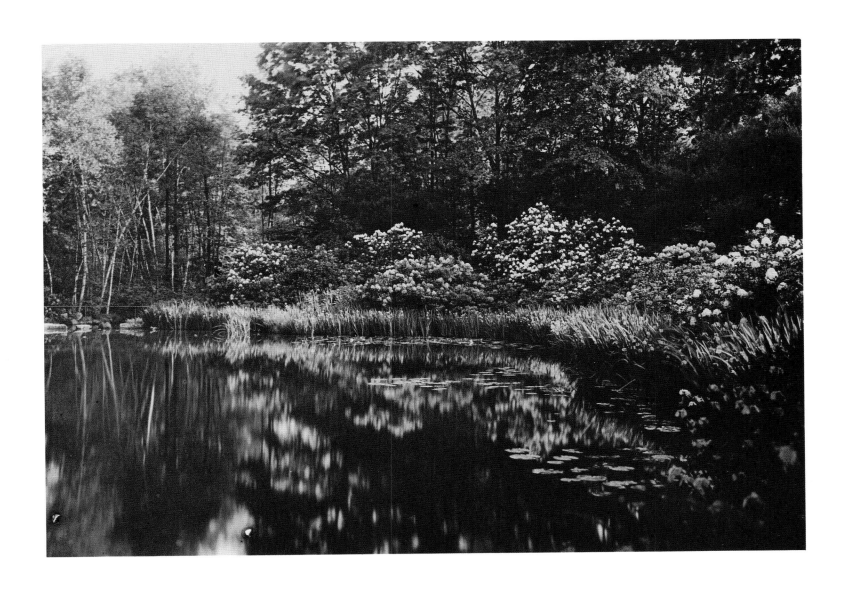

Arnold Arboretum, Boston, Massachusetts

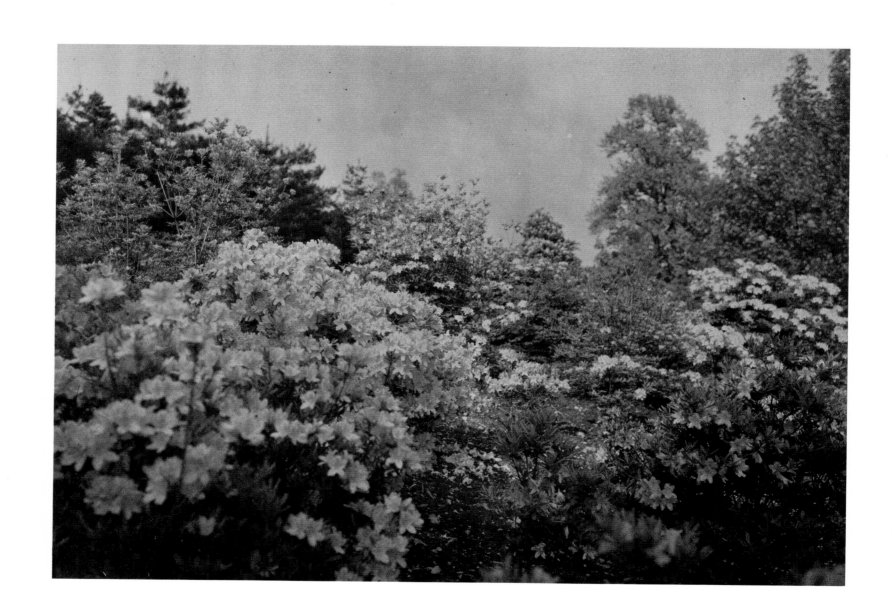

Location unknown

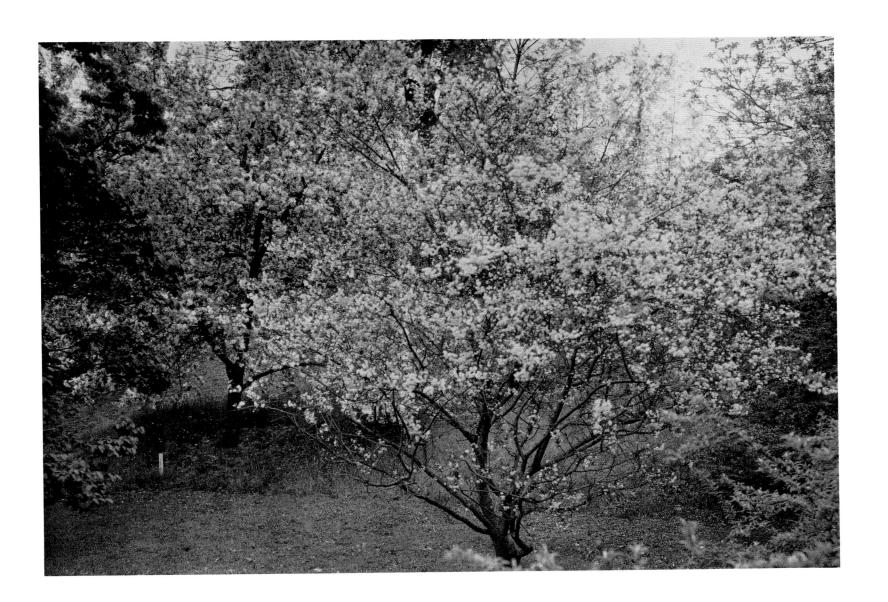

Location unknown

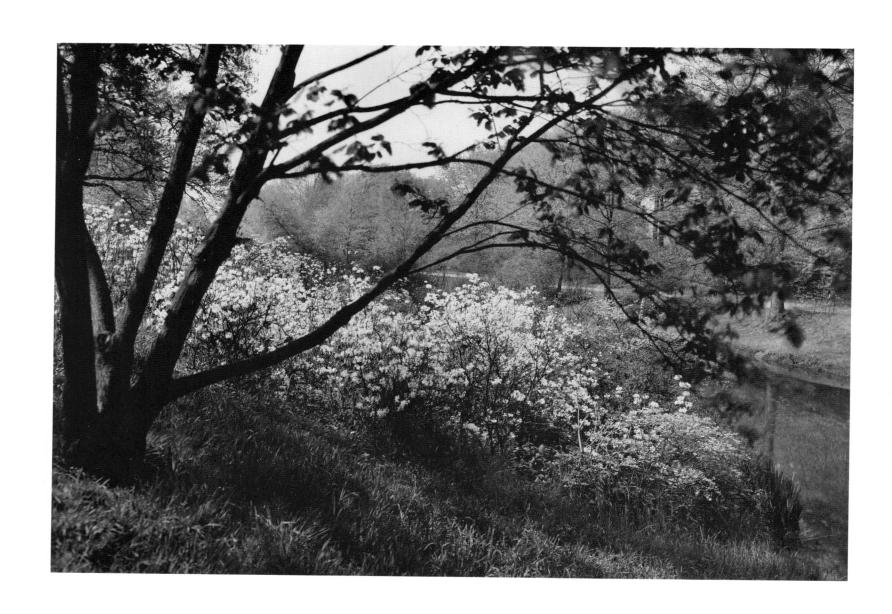

Arnold Arboretum, Boston, Massachusetts

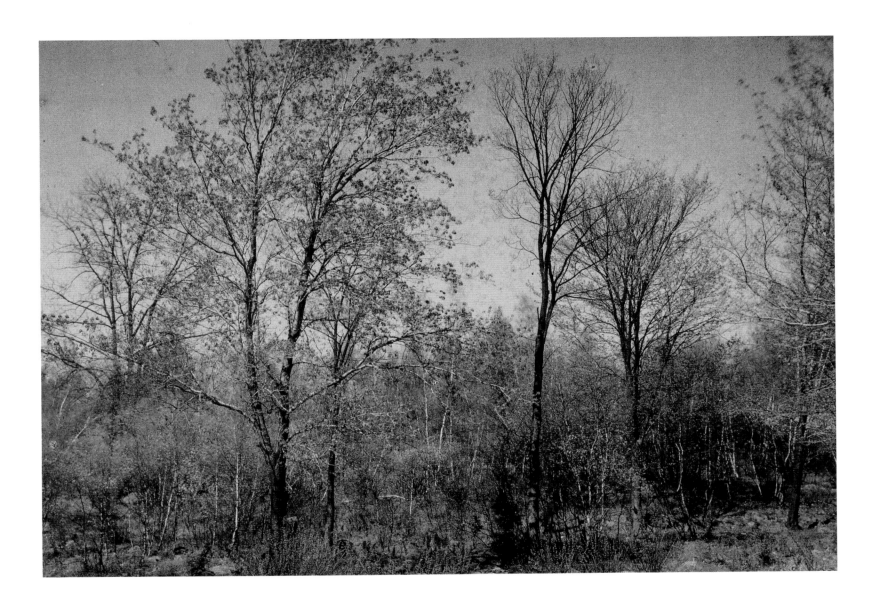

Location unknown

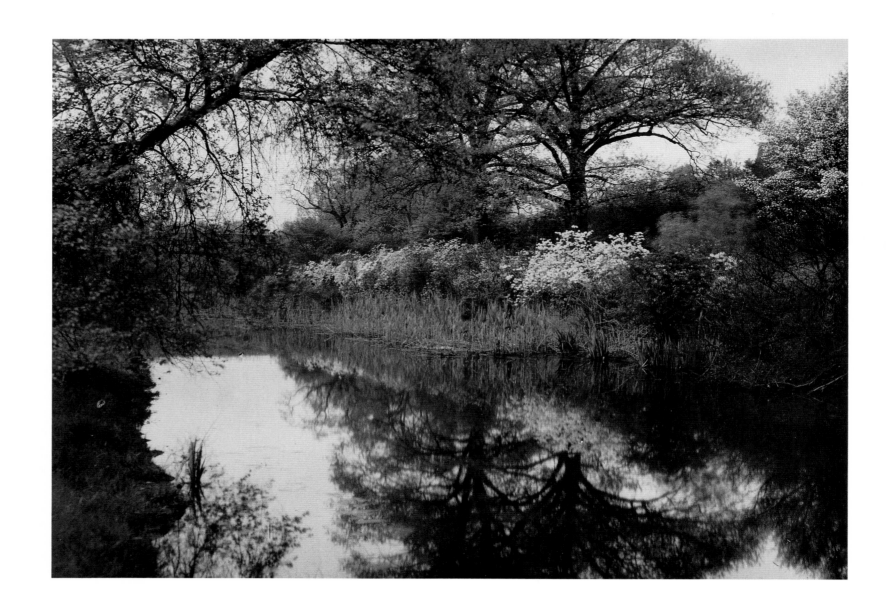

Arnold Arboretum, Boston, Massachusetts

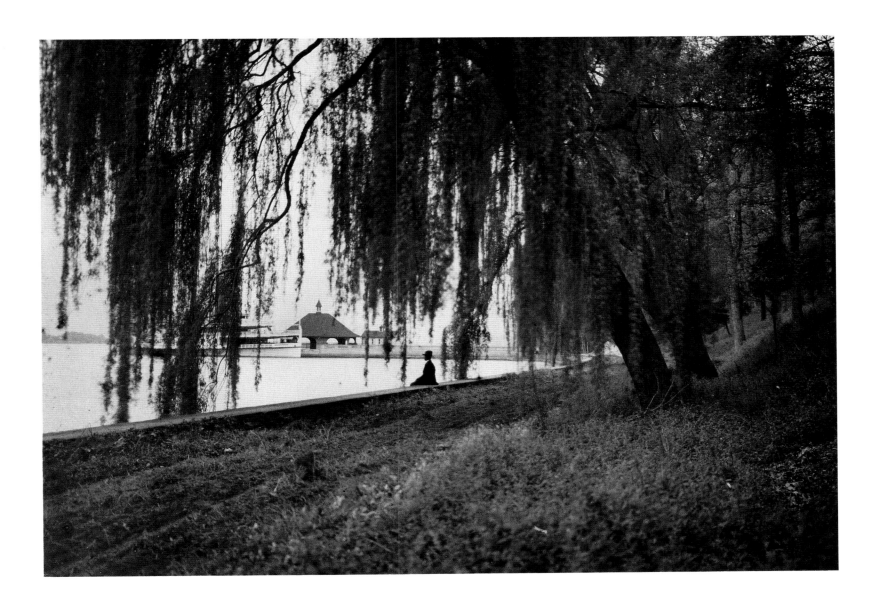

Location unknown

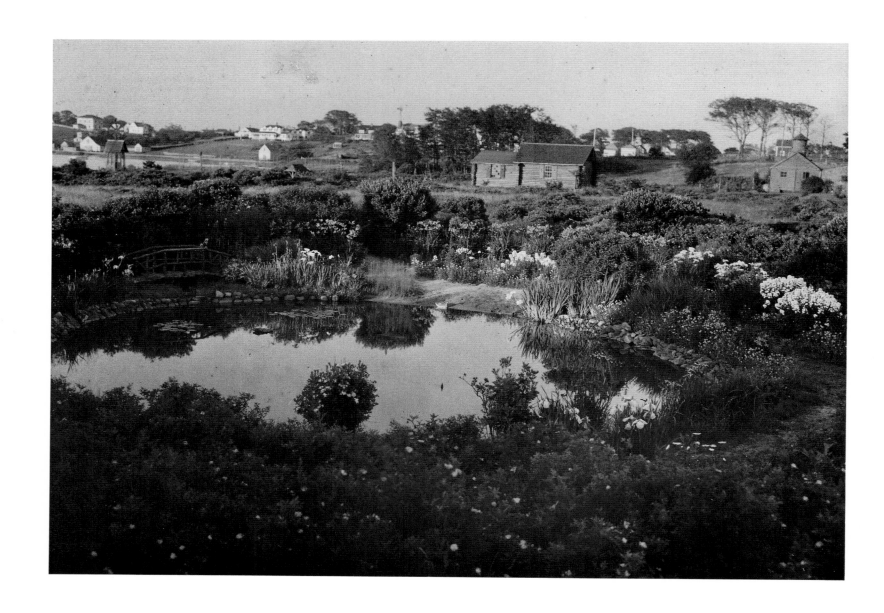

Cape Cod, Massachusetts

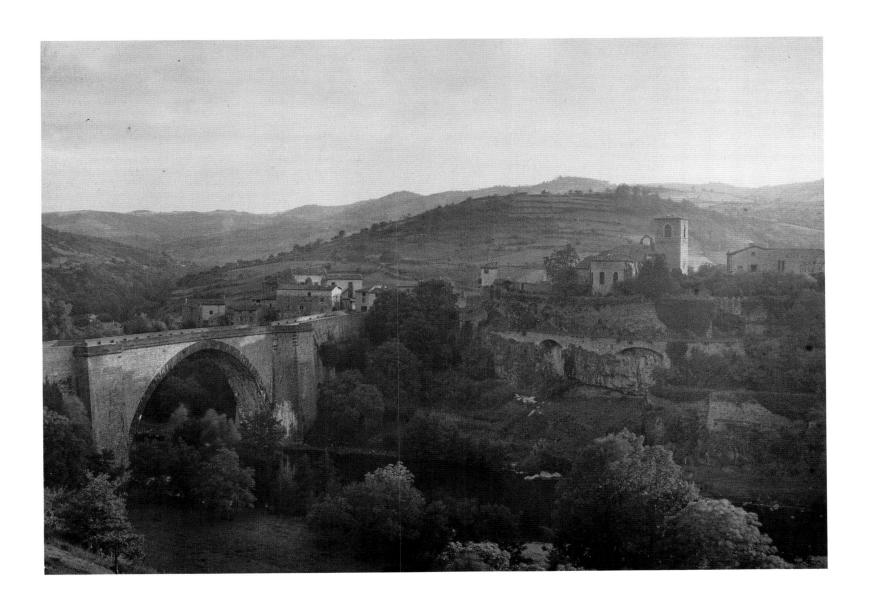

Italy

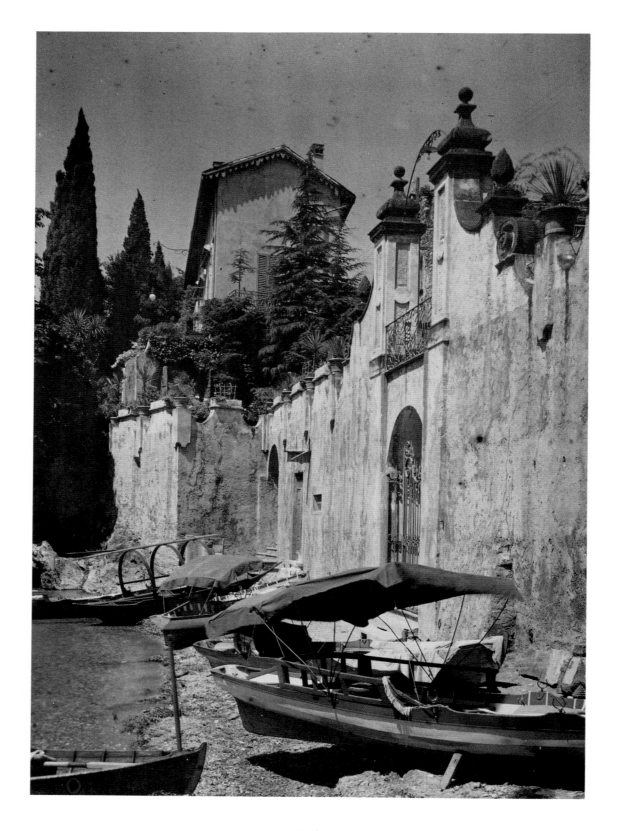

Italy

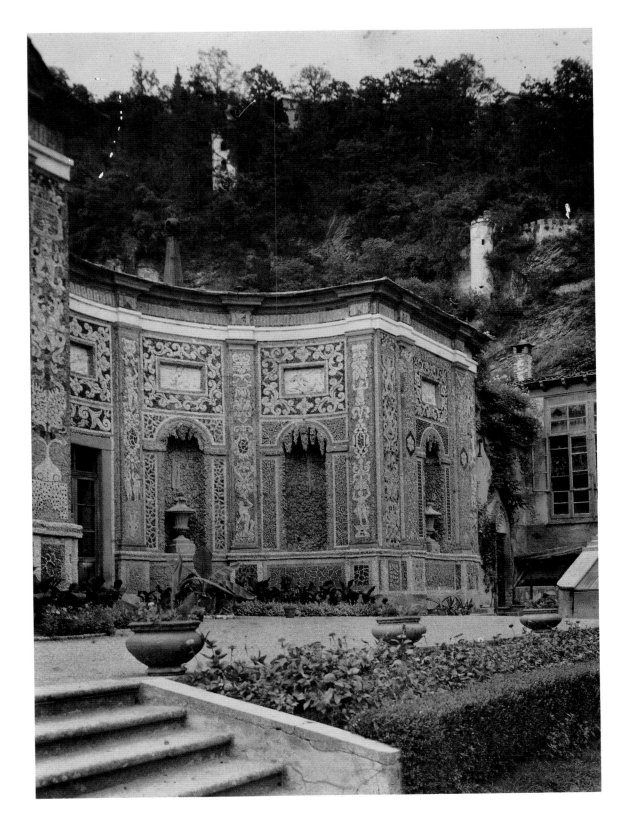

Italy

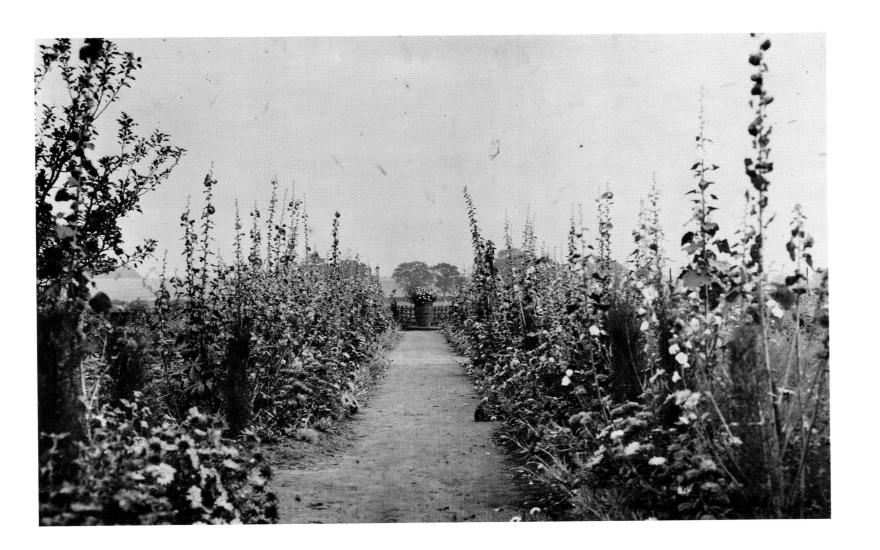

Location unknown

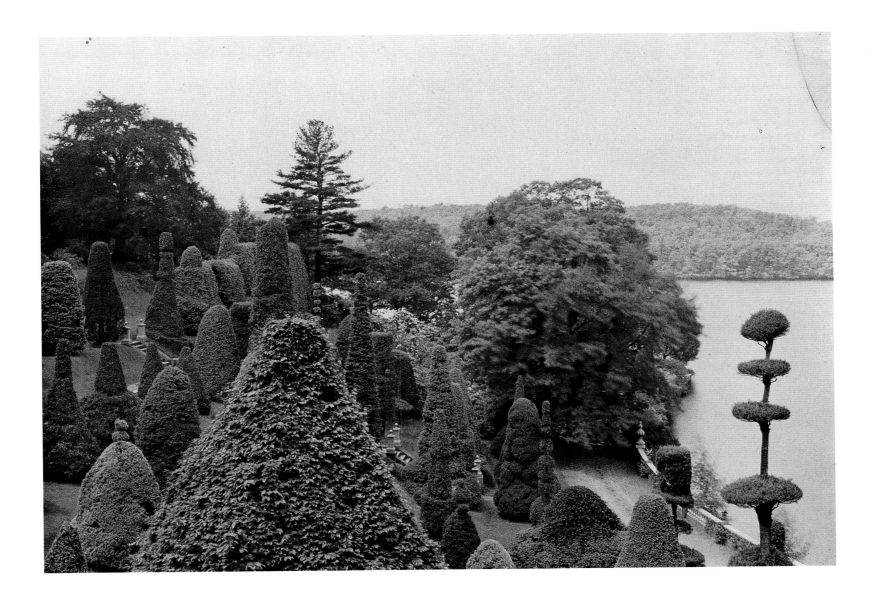

Topiary Garden, Wellesley, Massachusetts

This book was designed by Katy Homans, Homans | Salsgiver.
It was printed by Eastern Press.
The duotone plates were printed on 100# Mohawk Superfine text,
the color plates were printed on 100# Lustro dull text.
The typeface is Monotype Fournier and was typeset by Michael & Winifred Bixler.
The book was bound by
Mueller Trade Bindery and Publishers Book Bindery.

The Solio Foundation was established in 1984
to develop and administer exhibitions, publications and conservation projects in photography.
Through its publications and exhibitions
the Foundation hopes to enlarge the public awareness of photography.